DRAW 62 THINGS IN NATURE

AND MAKE THEM CUTE

STEP-BY-STEP DRAWING FOR CHARACTERS AND PERSONALITY

HEEGYUM KIM

QUARRY

CONTENTS

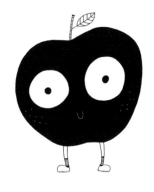

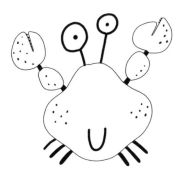
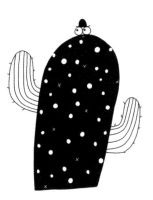
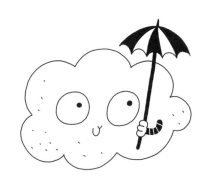
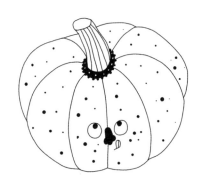

INTRODUCTION

I have always loved to draw. I started out drawing foods and objects and houses, but learning to draw nature felt like a big challenge. I slowly started exploring nature by drawing a leaf, a tree, a flower, and some others, and as I drew, I discovered that what was most fun was to develop a "personality" for each one.

When I began this book assignment, I had drawn many things in nature, but I soon realized that there were many I had never previously tried drawing. To understand the physical characteristics of a plant, insect, or other natural object, I do research before I start drawing, and I recommend you do the same. A quick online search or reference book will do the trick. Inevitably, this research also helps me not only to achieve a likeness, but also to imagine what kind of personality each thing might have. For example, I was already familiar with the name "axolotl," but I had no idea what one looked like. I soon discovered that an axolotl looks like cute little alien!

Drawing is a wonderful activity, whether you do it for recreation or aspire to do it professionally. Drawing improves creativity, memory, communication skills, and problem-solving skills. In addition to improving physical dexterity and brain/body coordination, drawing also provides stress relief and an outlet for emotions, plus it increases your emotional intelligence. Though I work full-time during the day as a graphic designer, I draw in the evenings as part of my daily routine. And I have whole weekends to dedicate to drawing! I find inspiration for my drawing everywhere: in my local surroundings, reading books, watching TV shows, observing people while waiting for coffee, and through conversation with friends. Browsing other artists' works on Instagram also inspires me a lot.

How to Use this Book

Use this book as a guide and reference to develop your own nature-inspired characters. On the left-hand page of each spread, follow along with the step-by-step guide of drawing the basic form. Concentrate on main geometric shapes that combine to make the figure. Then add identifying features such as ears, arms, or feet. Lastly, fill in the facial attributes that bring the character to life. After you master the basic drawing of the item, object, or animal, use the right-hand page to inspire further drawings in various poses, with various expressions, or engaging in particular activities. There are spaces throughout the book for you to draw, or you can work on separate sheets of paper or in a drawing pad or journal. Tips are sprinkled throughout to give you creative ideas and technique suggestions.

Experiment with a variety of drawing pencils and pens to get familiar with how they feel and the kind of marks they make. Most of the drawings here begin with pen or pencil lines and often feature colored pencil for variety.

Remember, the best way to get better at drawing is to draw! Set up a regular practice or find time when you can. I hope this book provides you with loads of fun ways to expand your drawing skills and your imagination.

DRAW A CLOUD

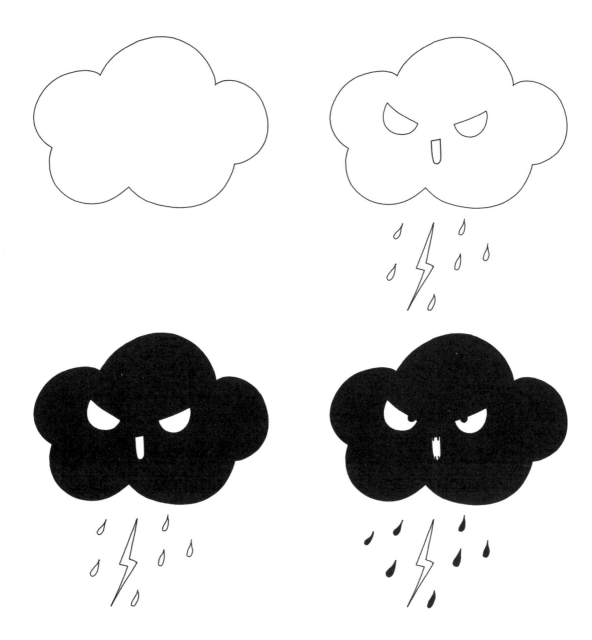

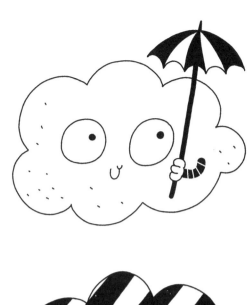

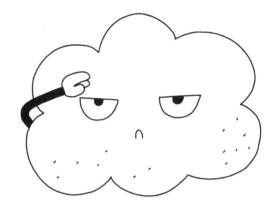

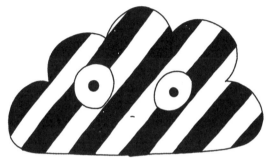

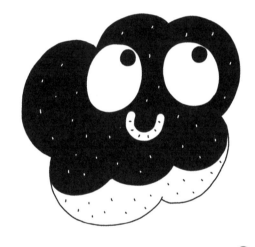

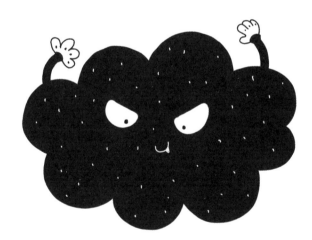

TRY IT!

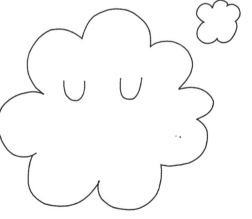

MAKE IT CUTE

DRAW A SHELL

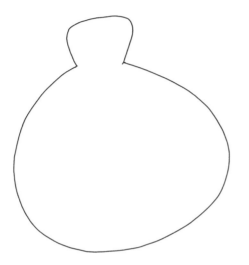
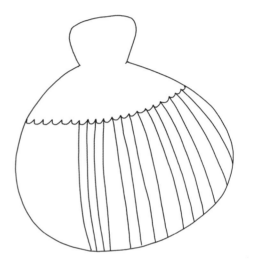

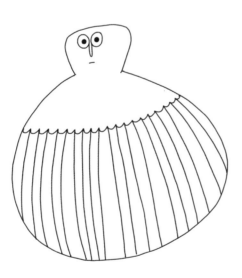
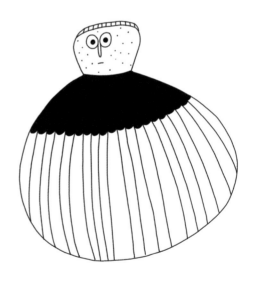

TRY IT!

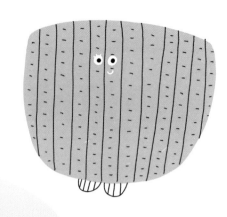

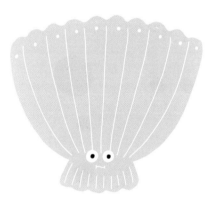

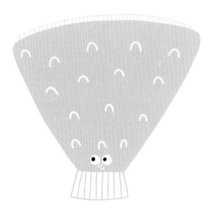

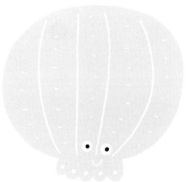

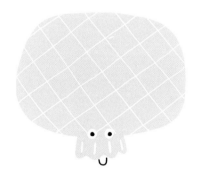

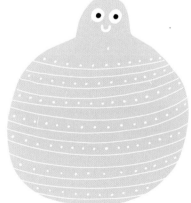

MAKE IT CUTE

DRAW A BUTTERFLY

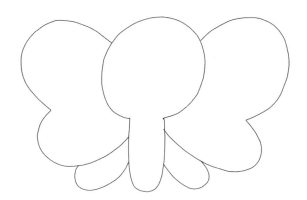

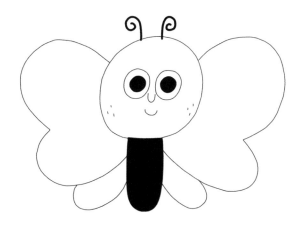

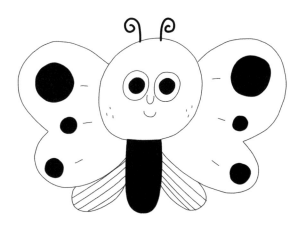

TRY IT!

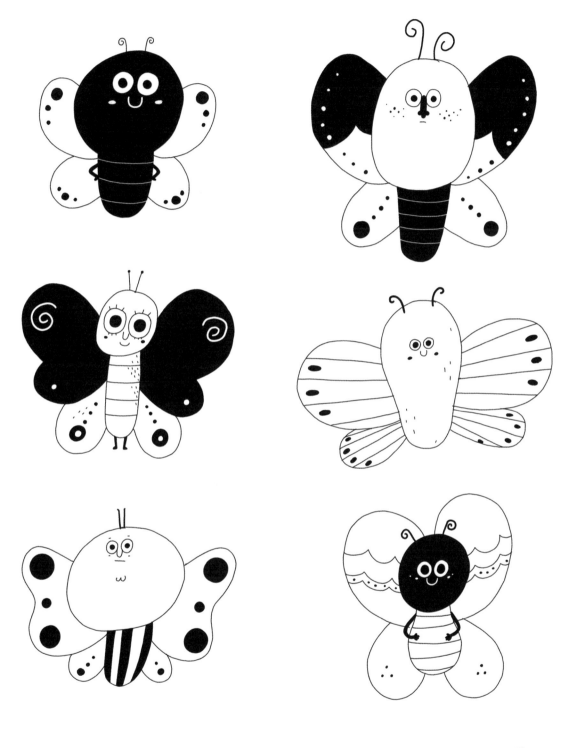

MAKE IT CUTE

9

DRAW A LOTUS

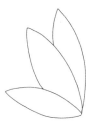
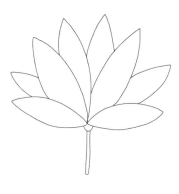
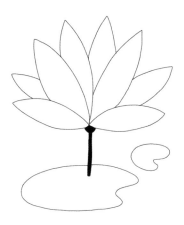

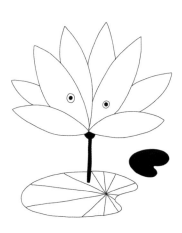
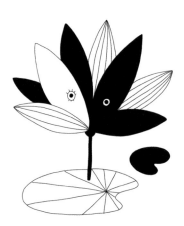

→**TIP**← When filling in the lotus petals, you can use any combination of colors and visual textures. Make all the petals the same, alternate colors and textures, or make each one different. And don't forget to add textural details to the stem as well.

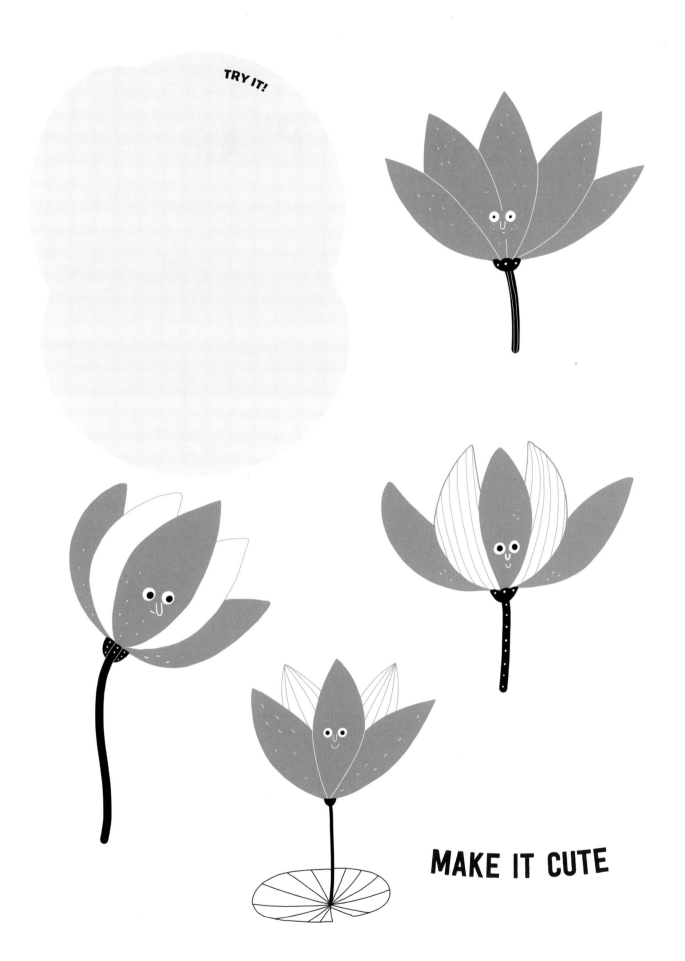

MAKE IT CUTE

DRAW A PEAR

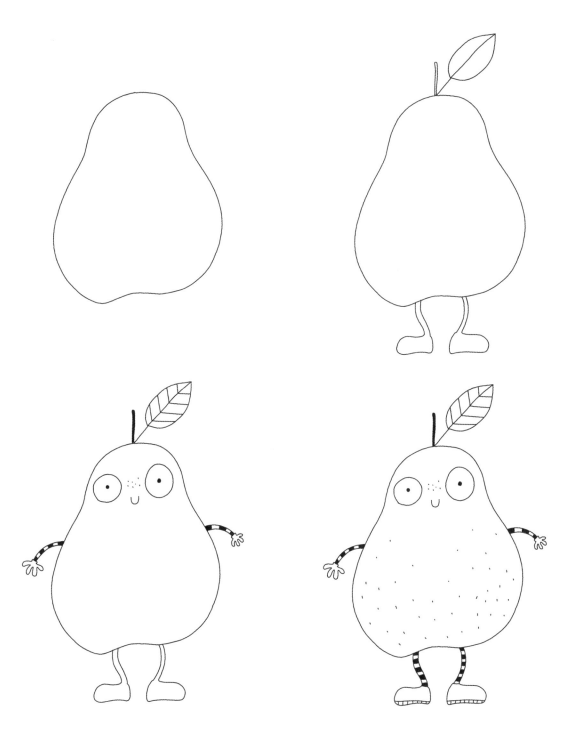

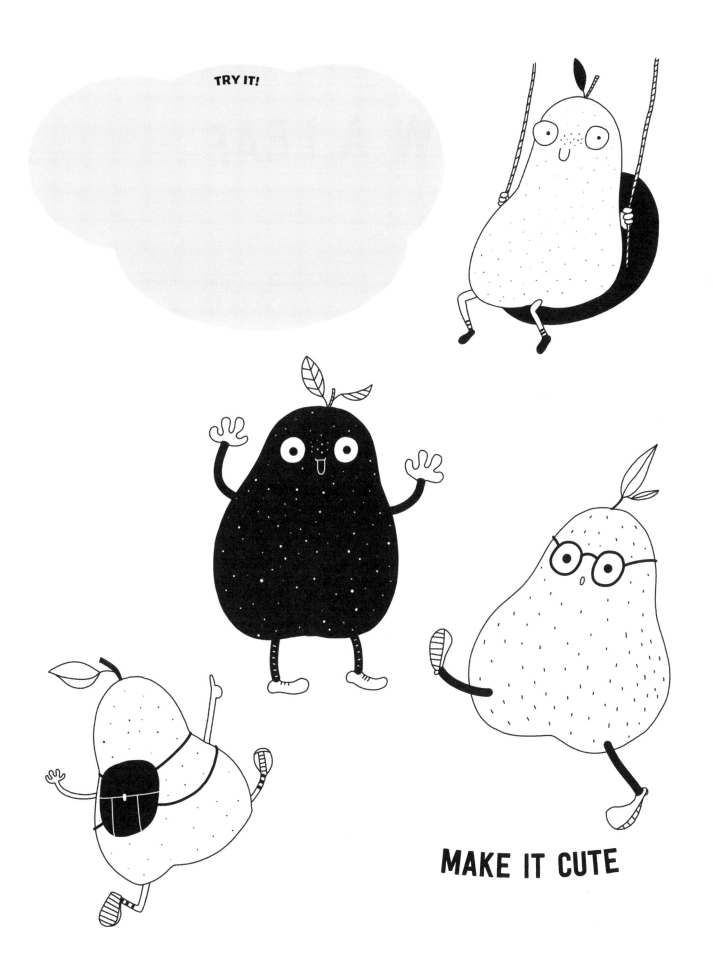

TRY IT!

MAKE IT CUTE

DRAW A LEAF

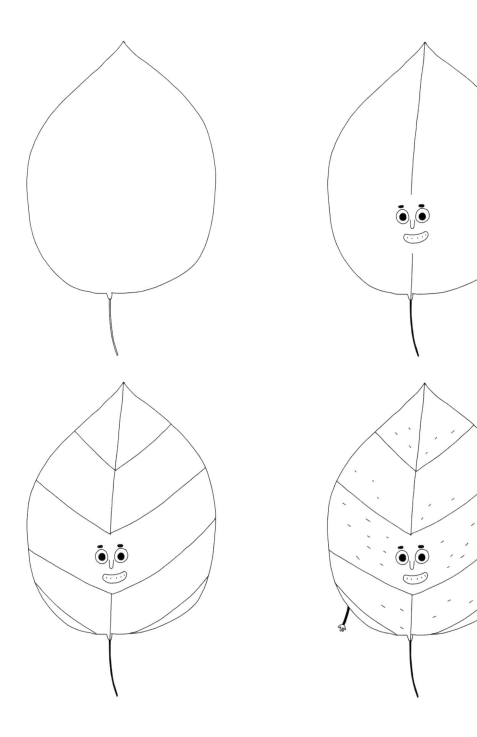

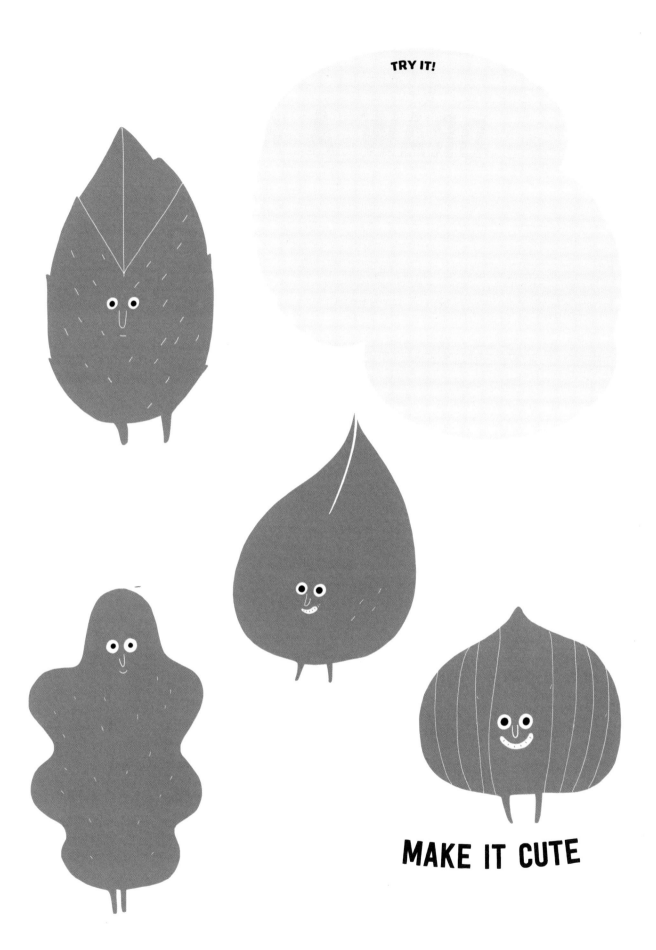

TRY IT!

MAKE IT CUTE

DRAW A BILBY

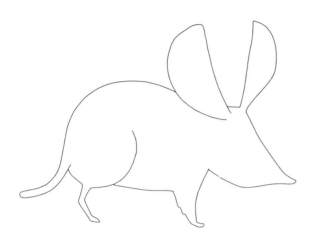

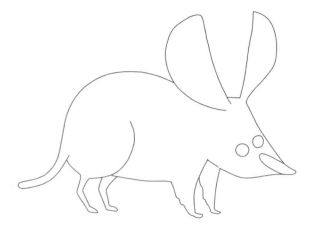

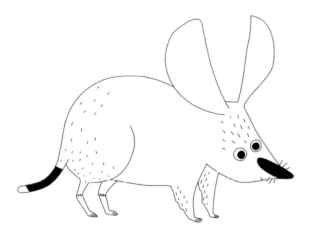

TRY IT!

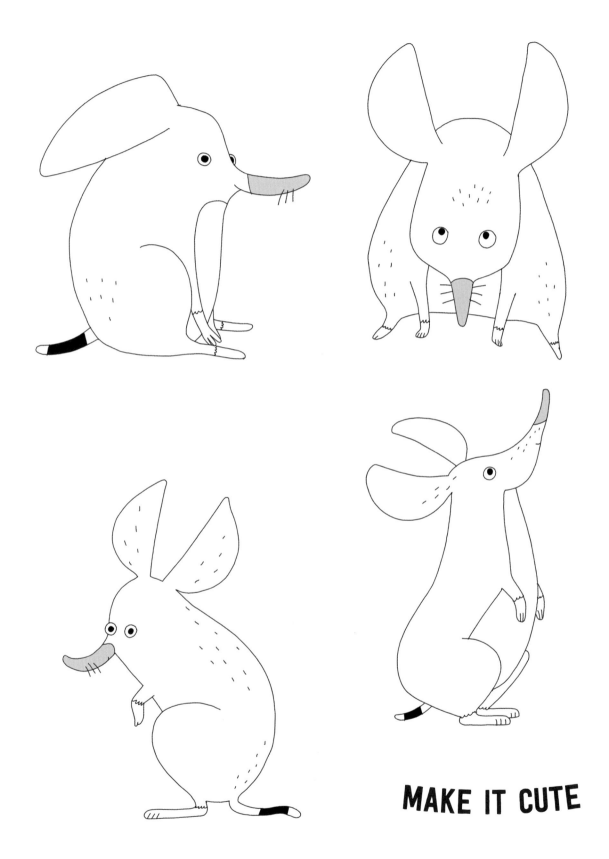

MAKE IT CUTE

DRAW A ROCK

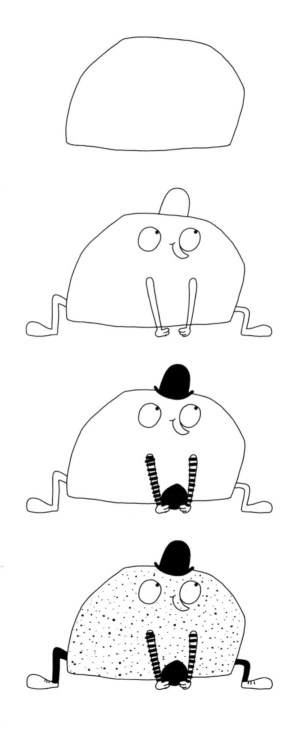

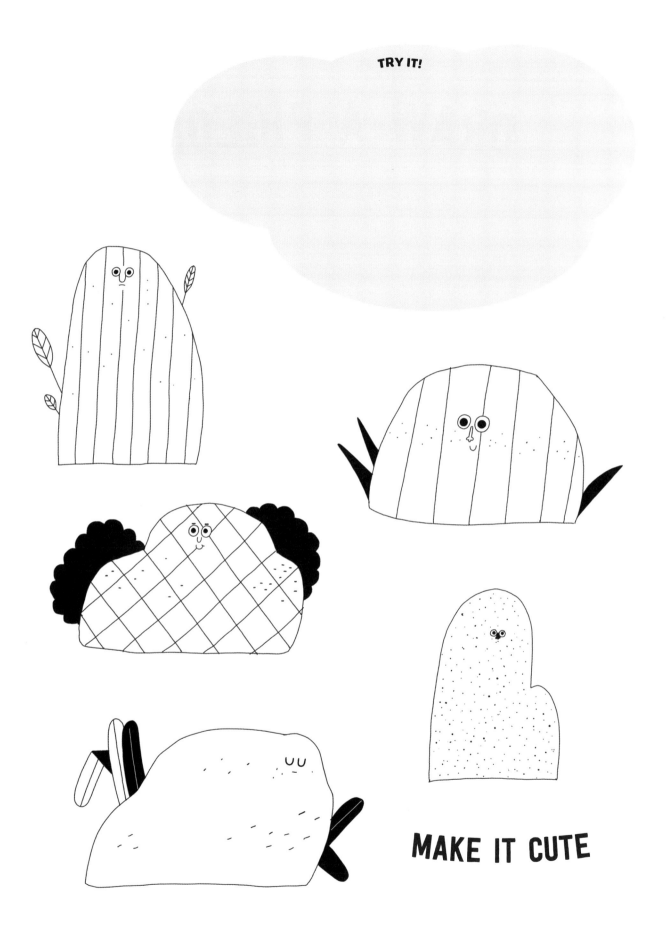

TRY IT!

MAKE IT CUTE

DRAW A PIGEON

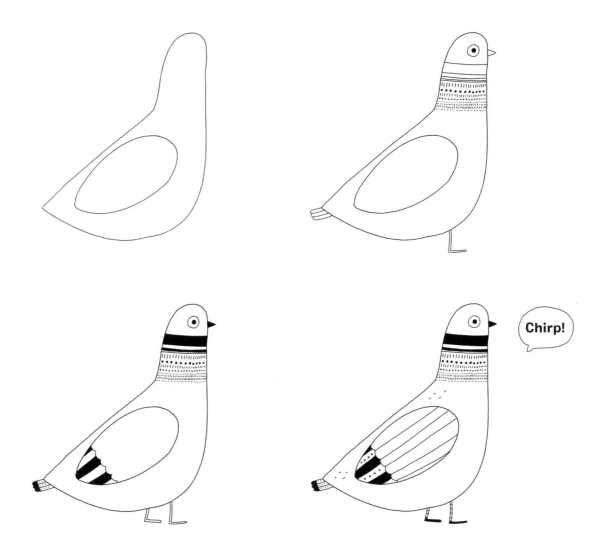

Chirp!

→ **TIP** ← You can draw a pigeon using the classic outline shown in the steps, or alter it to make it even cuter! Elongate the entire body, widen the tummy, or make a complete departure and start with an oval.

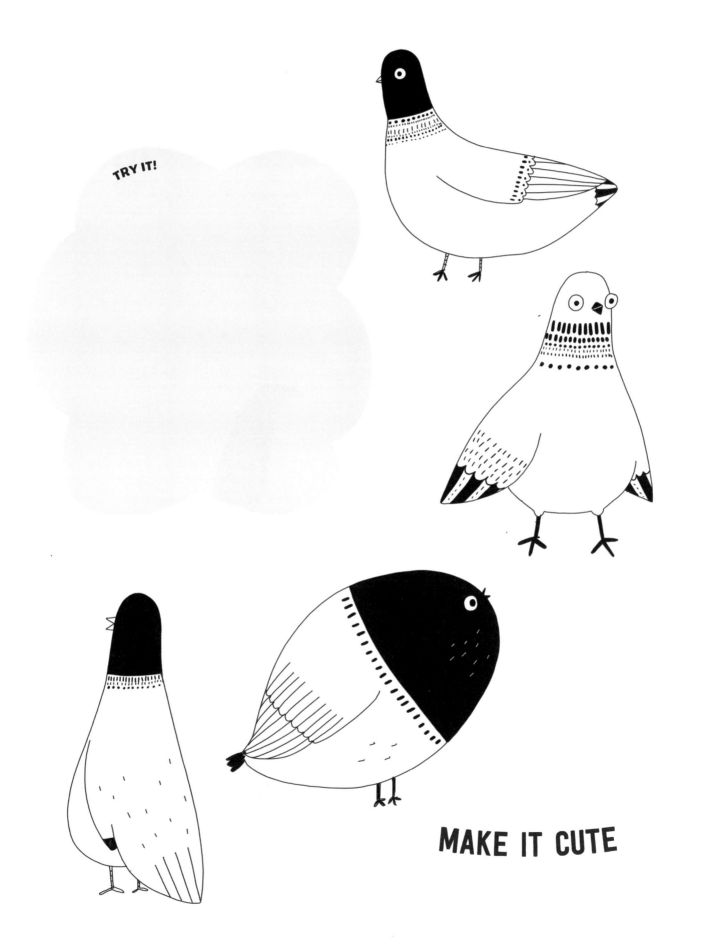

TRY IT!

MAKE IT CUTE

DRAW AN EAR OF CORN

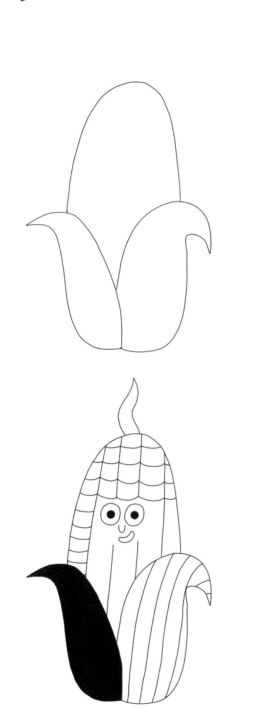

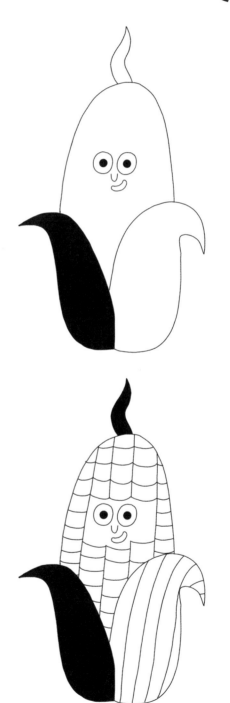

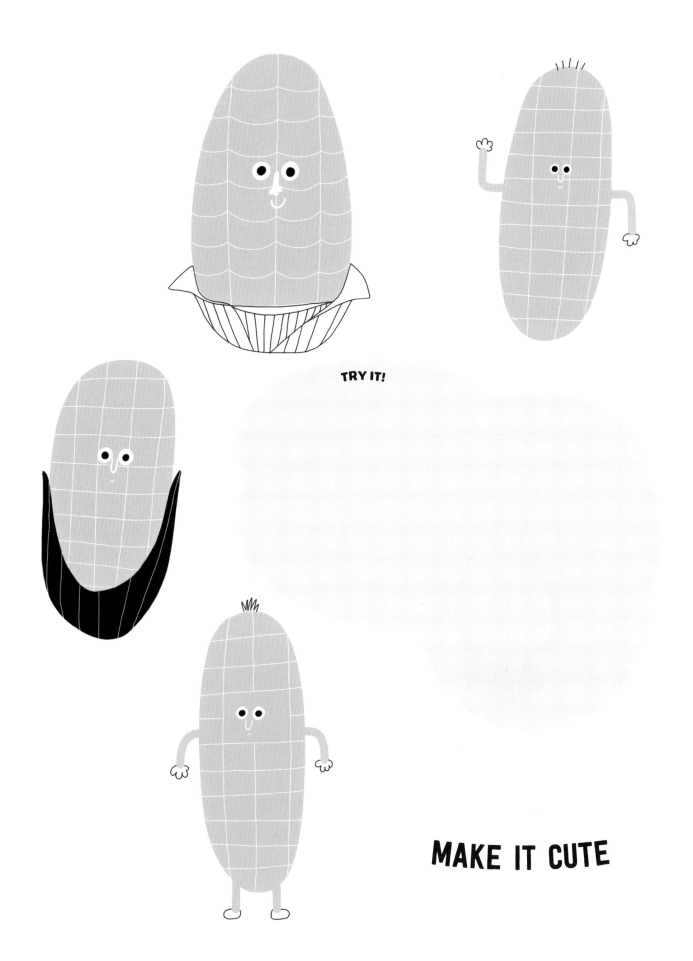

TRY IT!

MAKE IT CUTE

DRAW A BEETLE

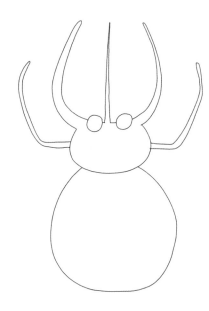

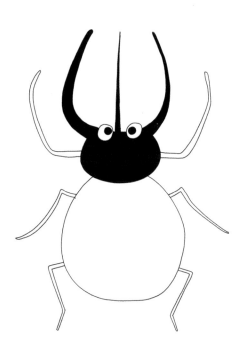

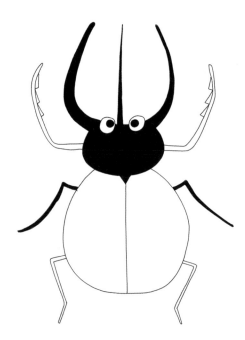

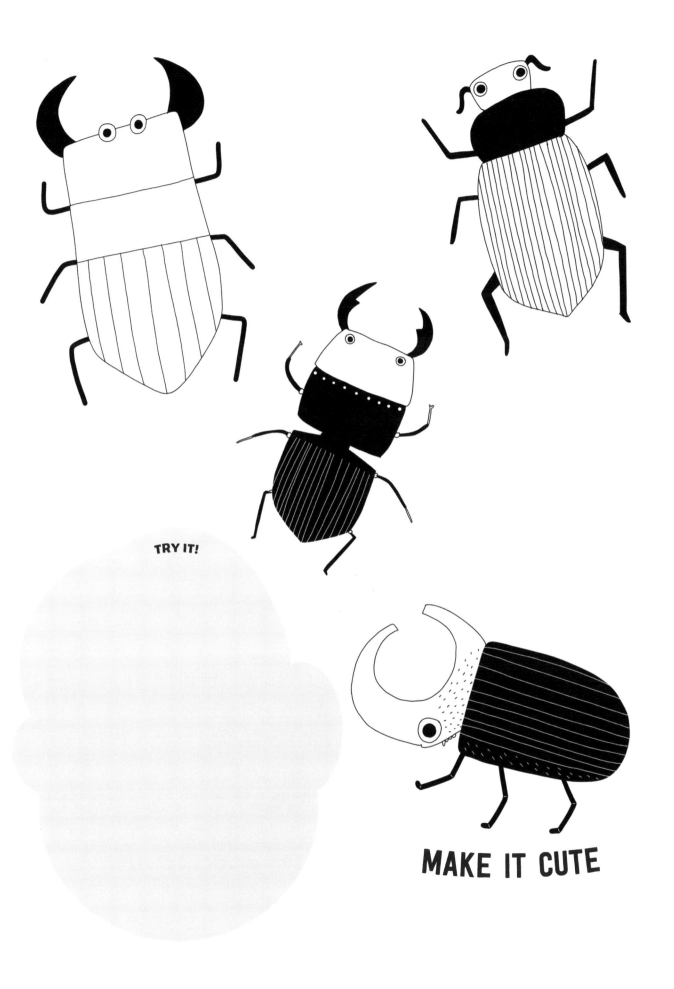

TRY IT!

MAKE IT CUTE

DRAW A NUT

TRY IT!

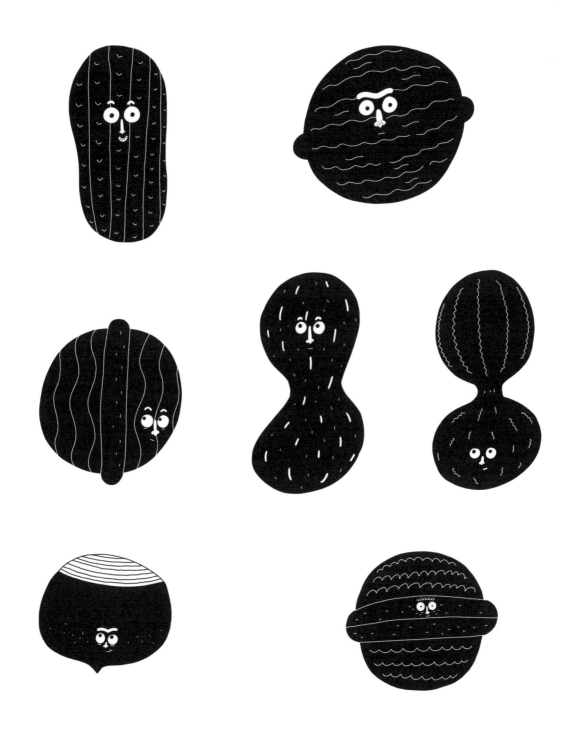

MAKE IT CUTE

DRAW A STRAWBERRY

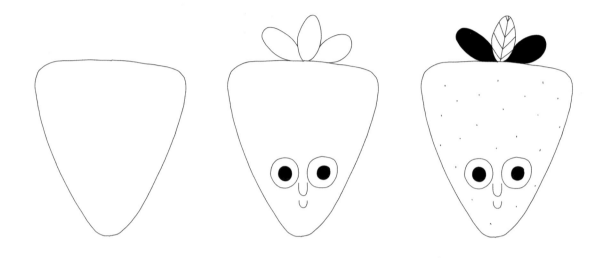

TRY IT!

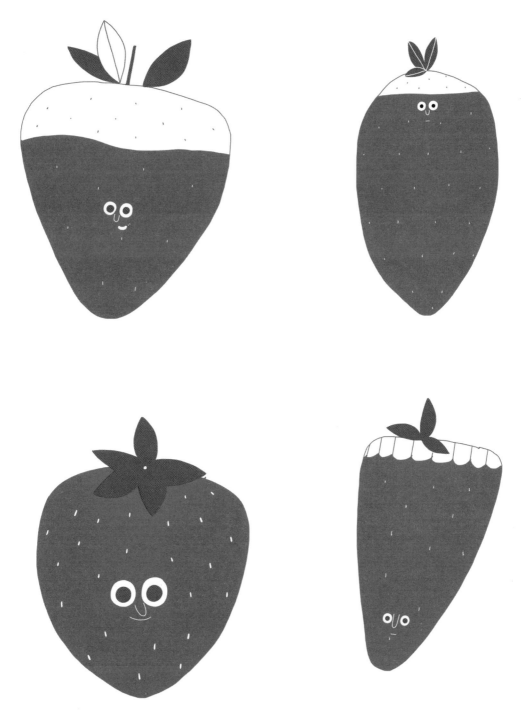

MAKE IT CUTE

DRAW A TREE

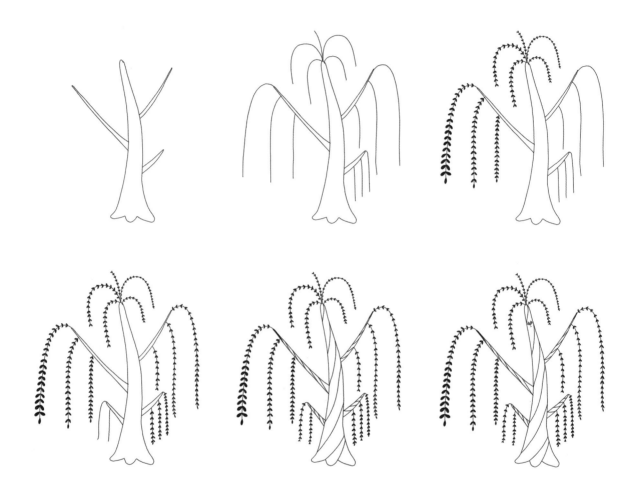

→ **TIP** ← Although the leaves on the willow tree shown in the steps vary in size but are all the same shape, you can take your tree in a unique creative direction, using a different type of leaf on each branch, or alternating flowers and leaves along their length.

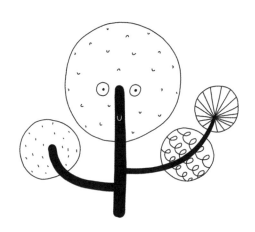

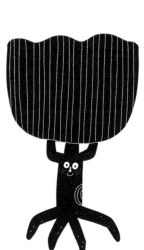

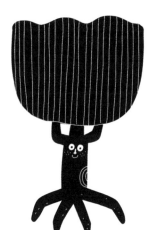

TRY IT!

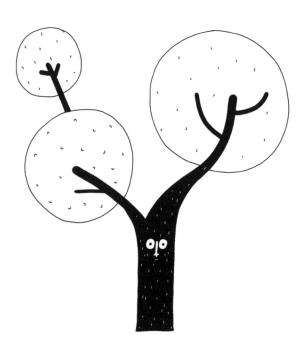

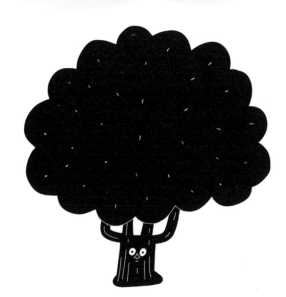

MAKE IT CUTE

DRAW A BISON

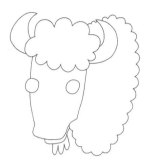

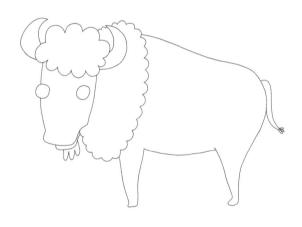

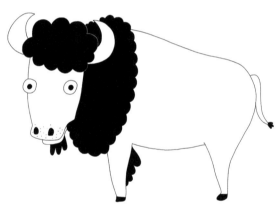

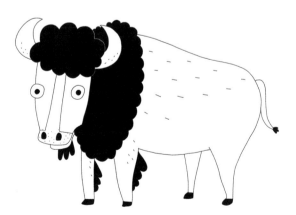

TRY IT!

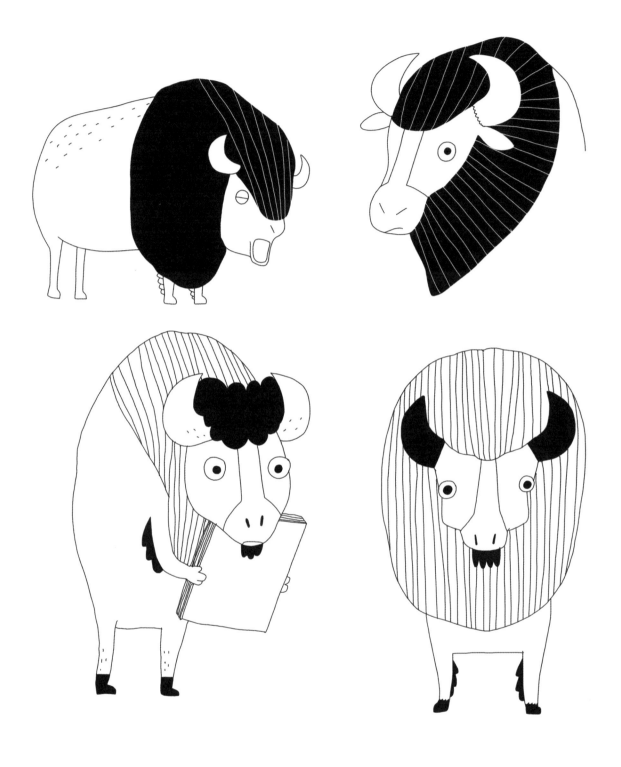

MAKE IT CUTE

DRAW A CRAB

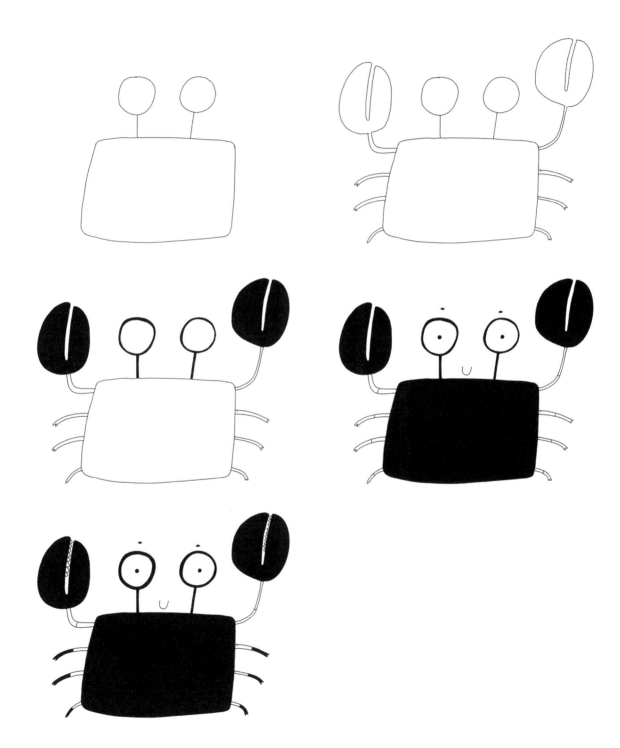

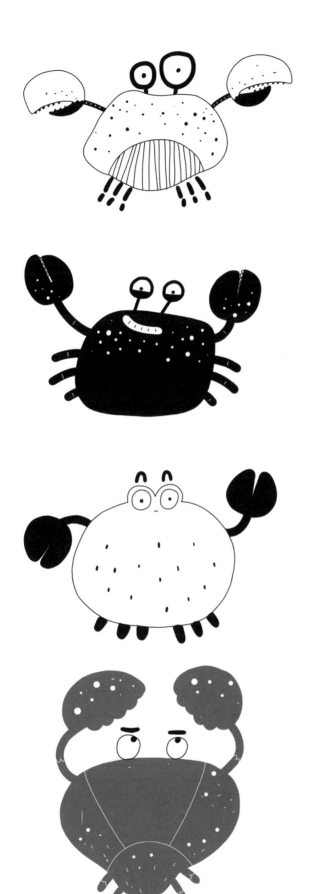

TRY IT!

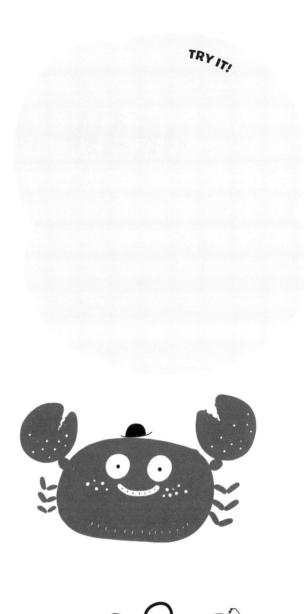

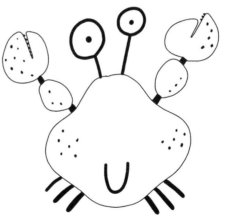

MAKE IT CUTE

DRAW A FENNEL

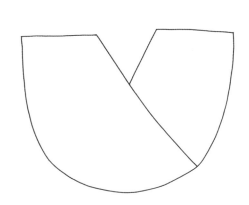
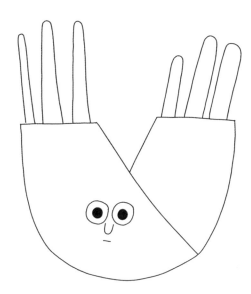
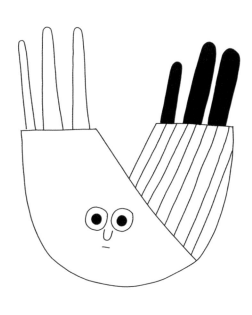
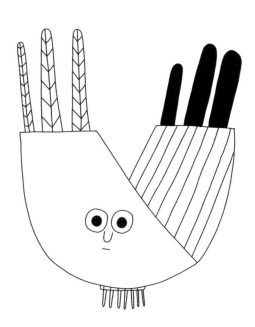

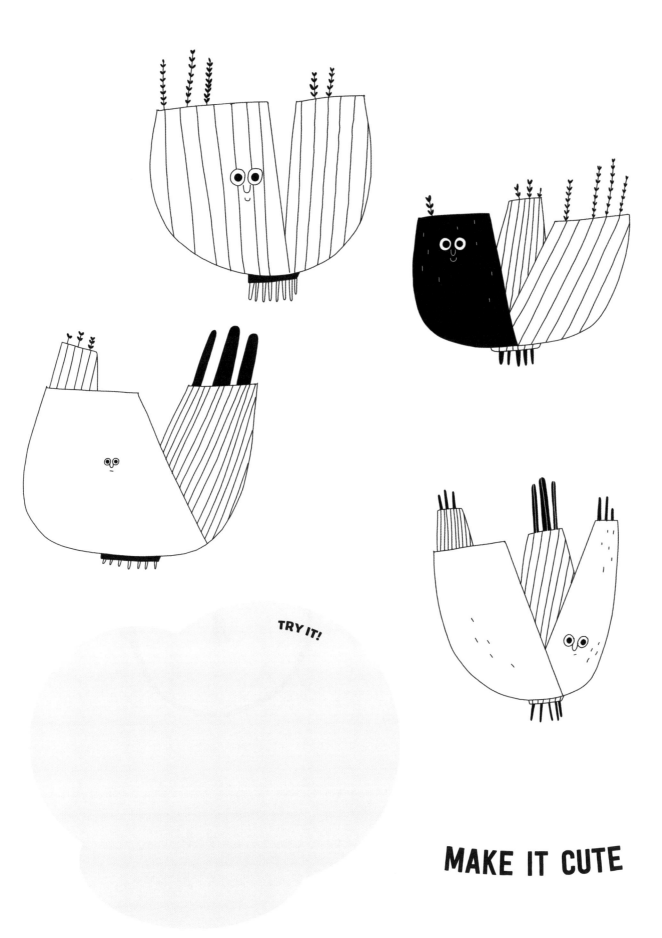

TRY IT!

MAKE IT CUTE

DRAW A SUN

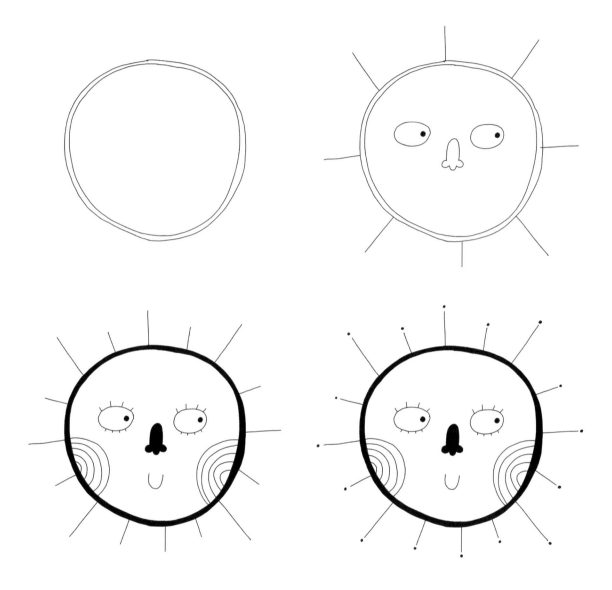

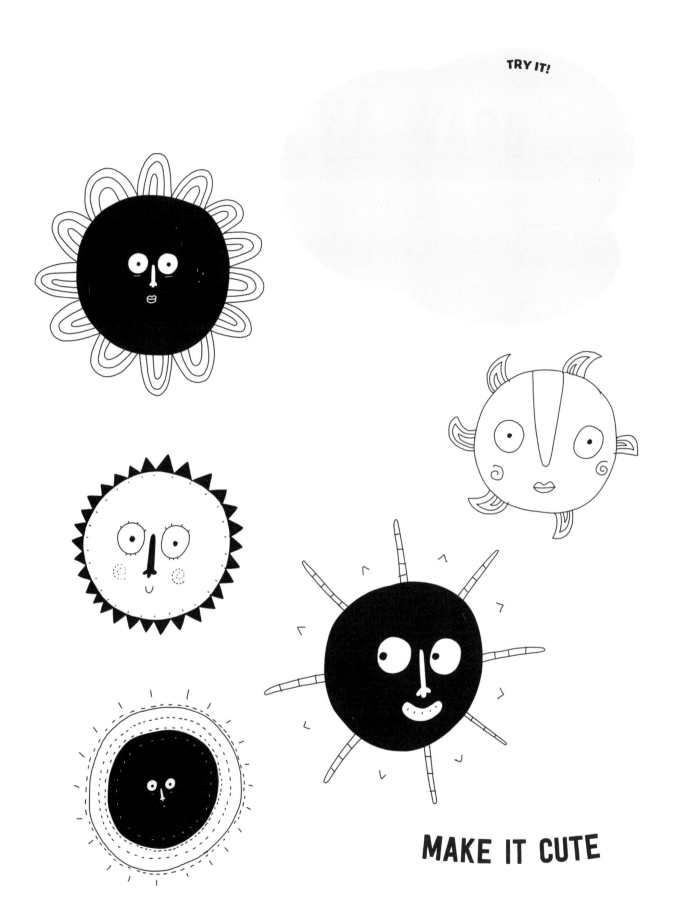

MAKE IT CUTE

DRAW AN EAGLE

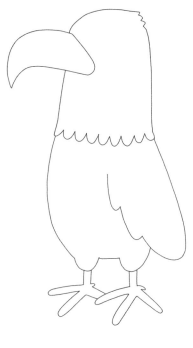

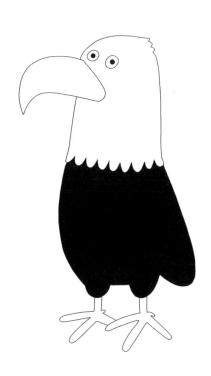

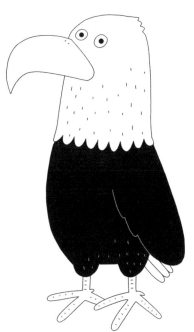

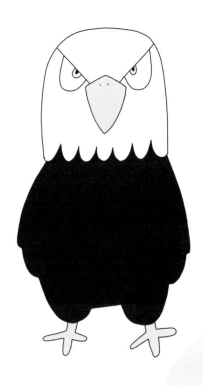

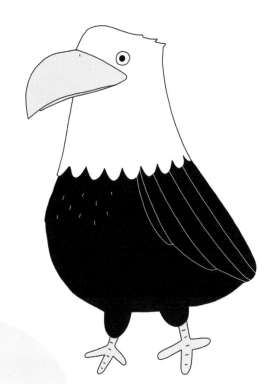

TRY IT!

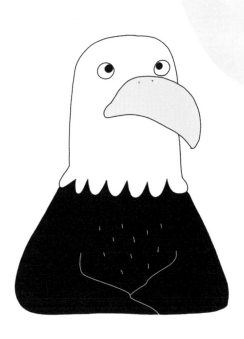

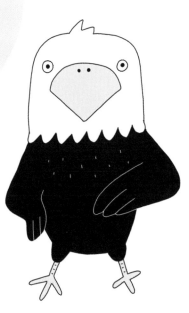

MAKE IT CUTE

DRAW A LADYBUG

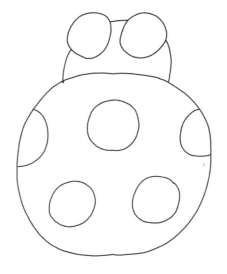

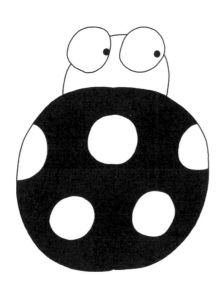

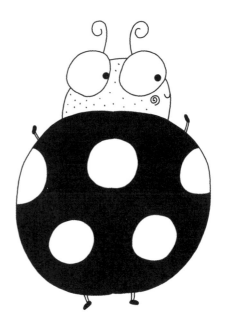

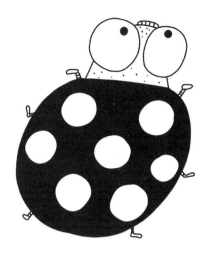

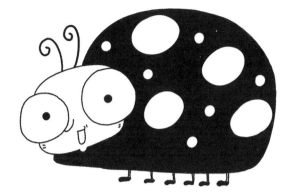

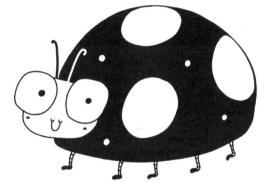

TRY IT!

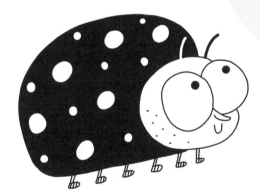

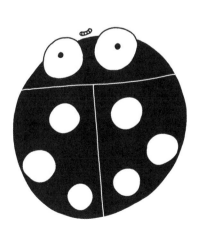

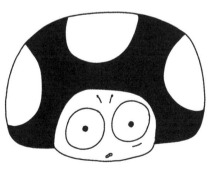

MAKE IT CUTE

DRAW A TULIP

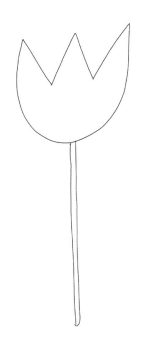

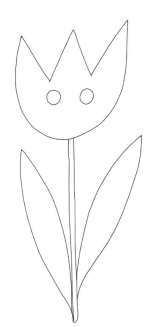

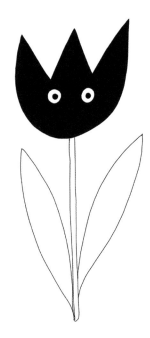

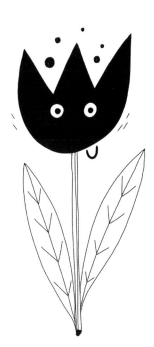

TRY IT!

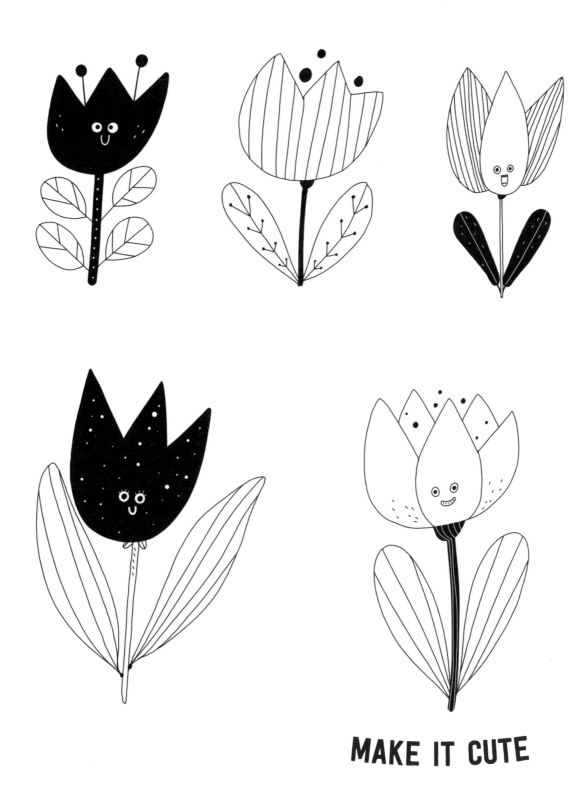

MAKE IT CUTE

DRAW A HABANERO

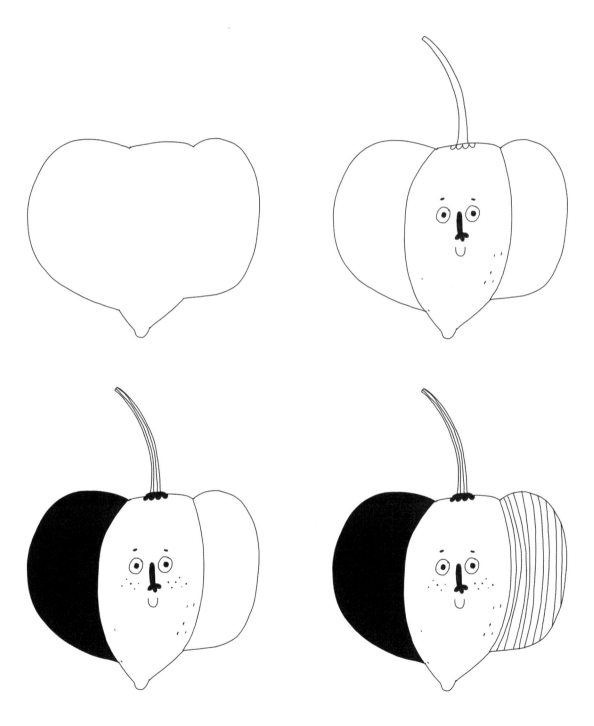

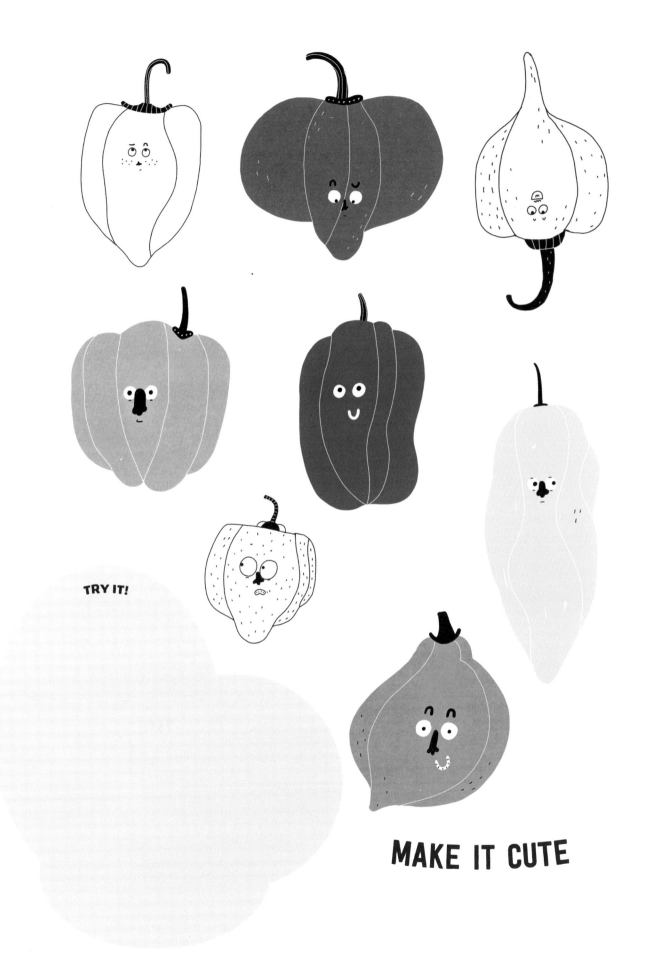

TRY IT!

MAKE IT CUTE

DRAW A CORAL

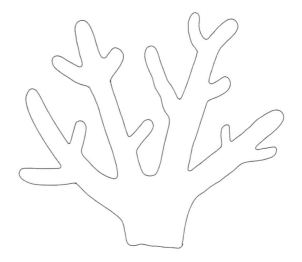

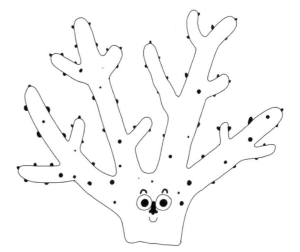

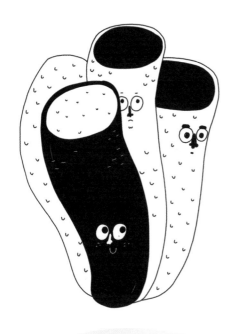

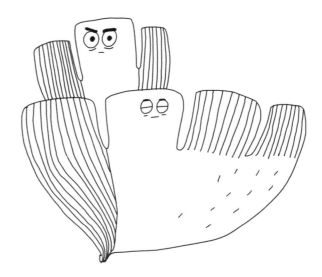

TRY IT!

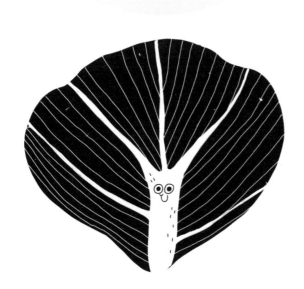

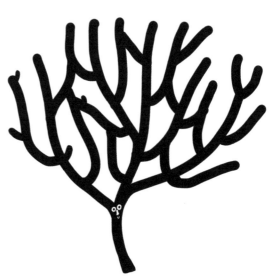

MAKE IT CUTE

DRAW A LION

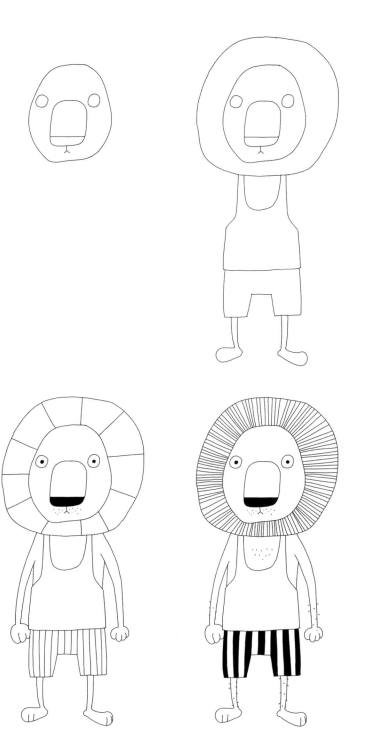

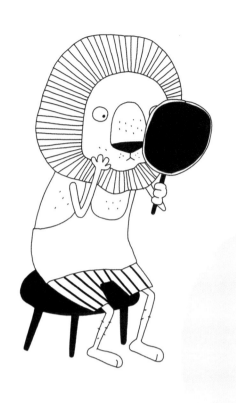

TRY IT!

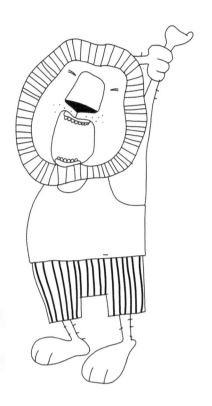

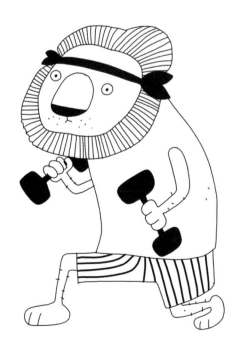

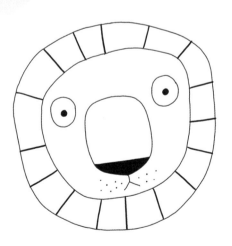

MAKE IT CUTE

DRAW A MUSHROOM

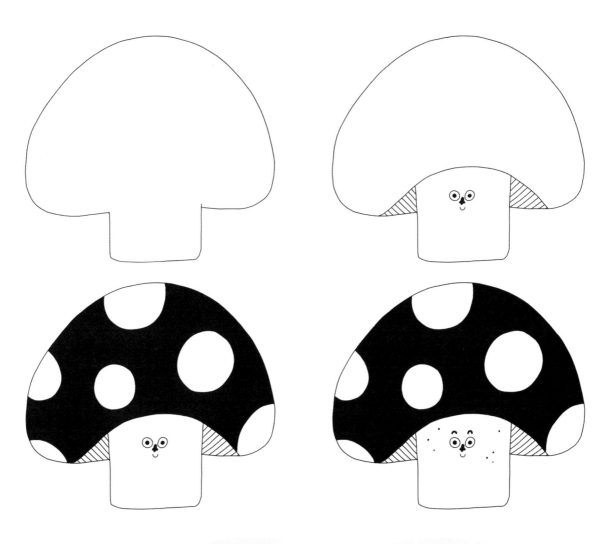

TRY IT!

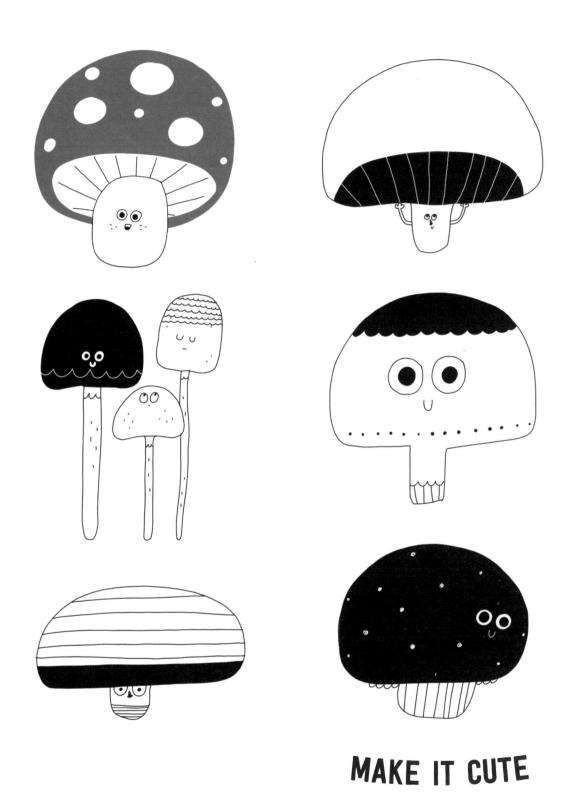

MAKE IT CUTE

DRAW A WATERMELON

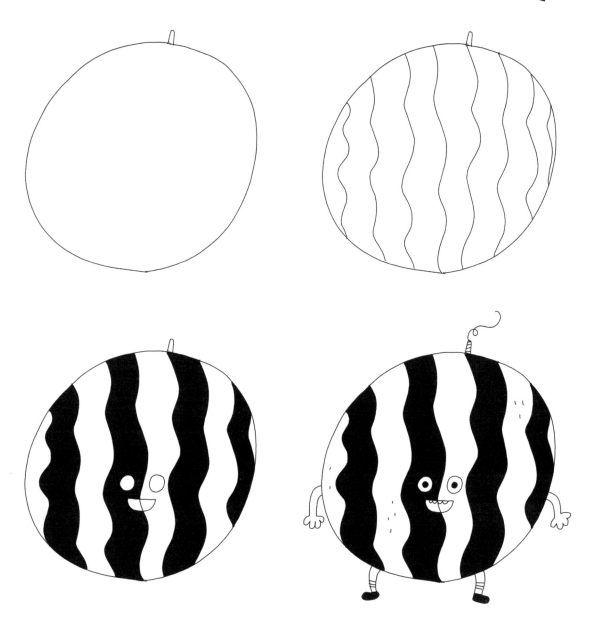

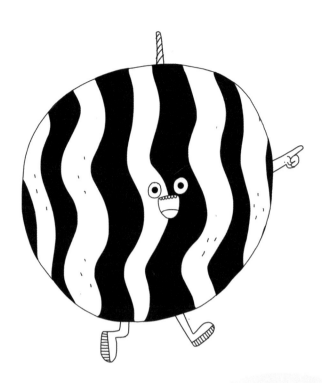

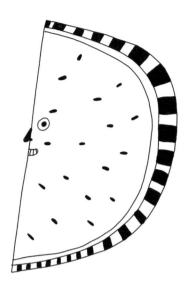

TRY IT!

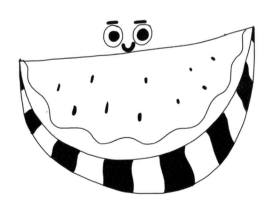

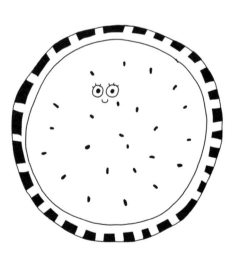

MAKE IT CUTE

DRAW A STINGRAY

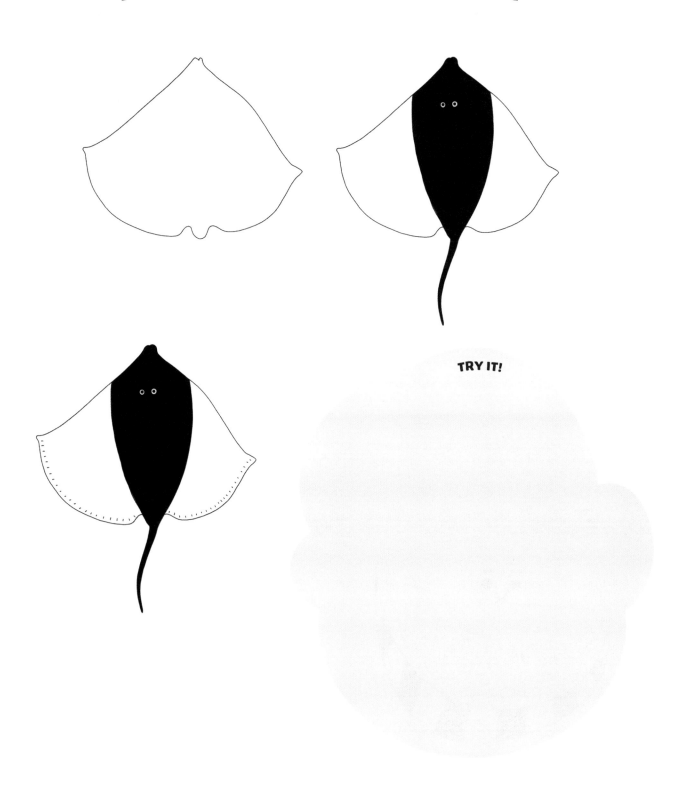

TRY IT!

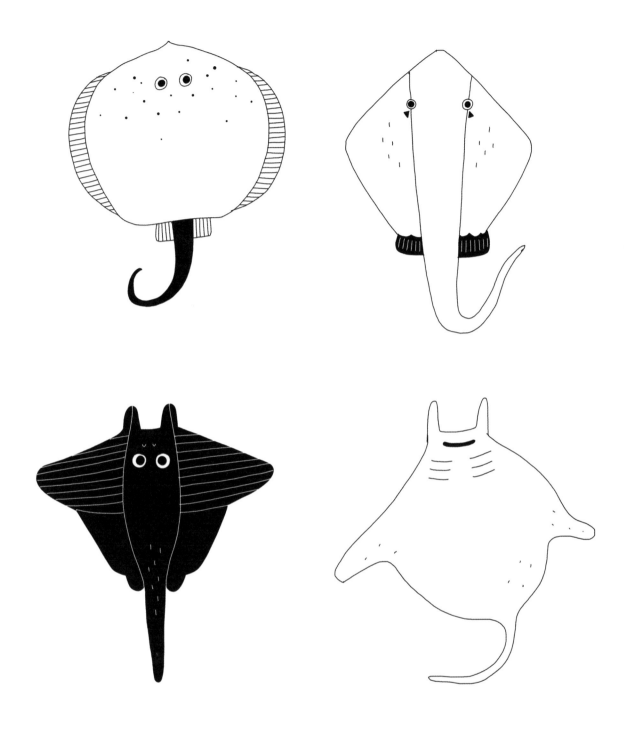

→**TIP**← In addition to the classic diamond shape, stingrays can also be round or kite-shaped, and some even have thick, fish-like bodies and tails. Even if you think you know what an animal looks like, it helps to do research before you start drawing so you have more creative options.

MAKE IT CUTE

DRAW A BANANA

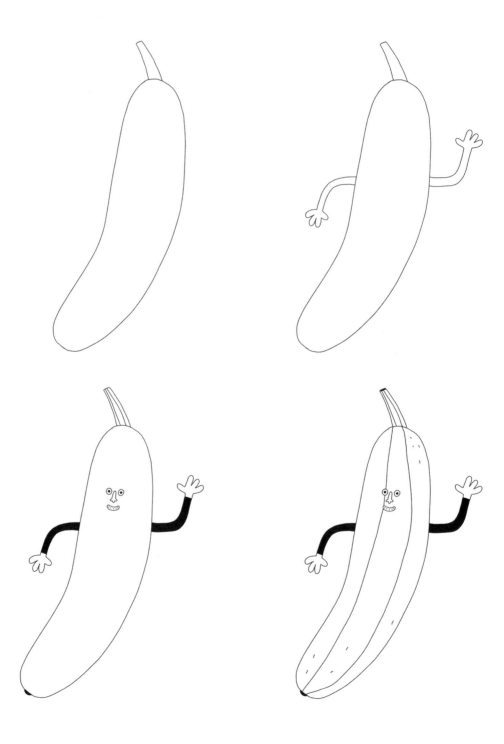

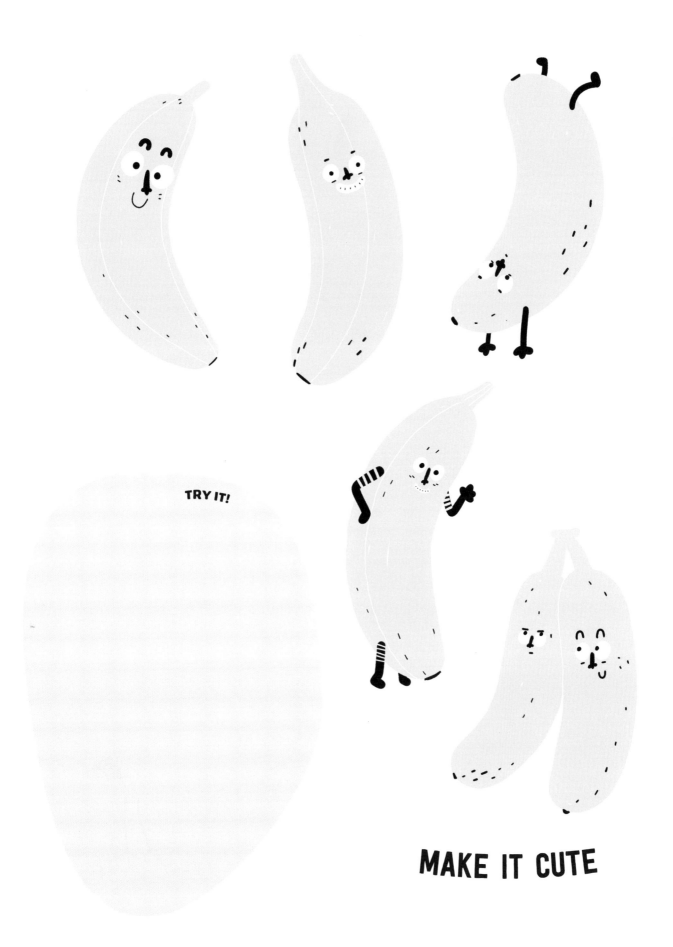

TRY IT!

MAKE IT CUTE

DRAW A STORK

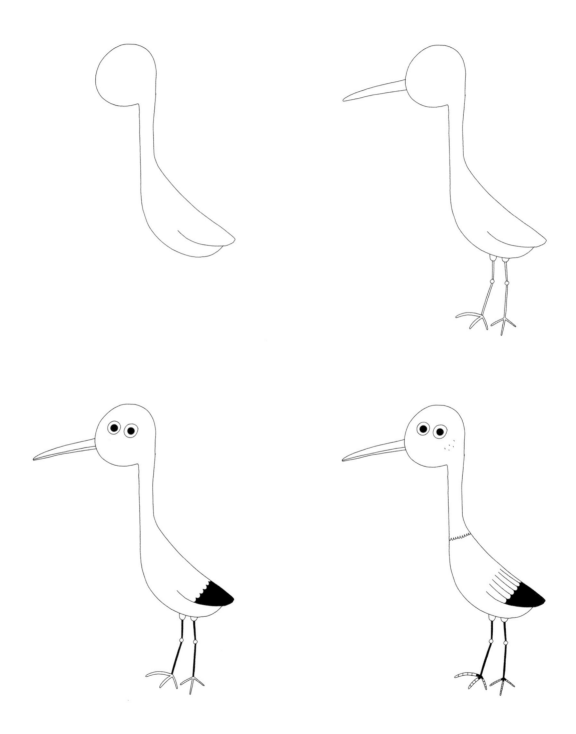

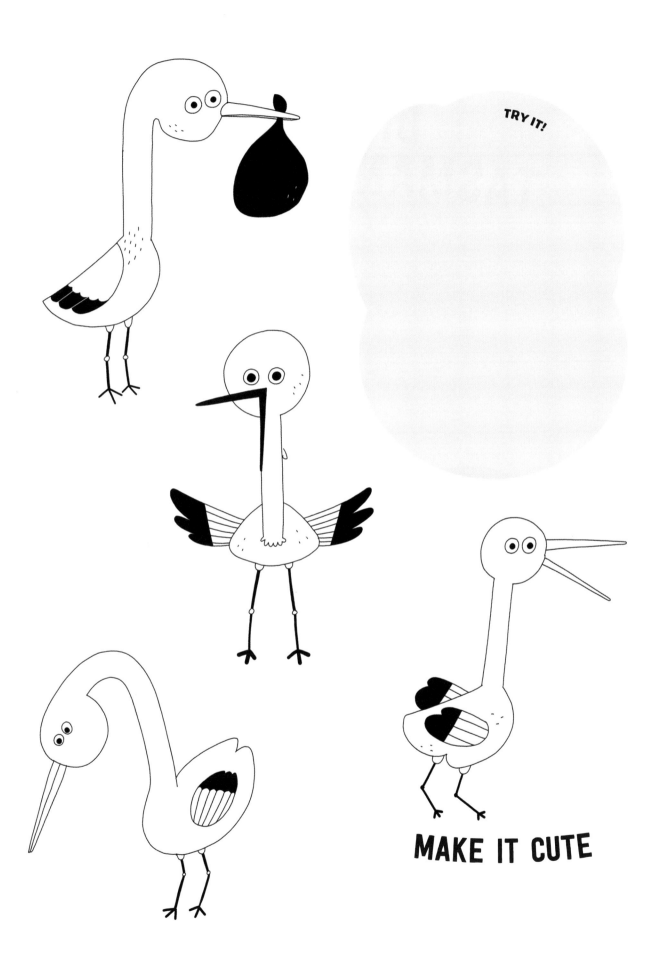

MAKE IT CUTE

DRAW A TASMANIAN DEVIL

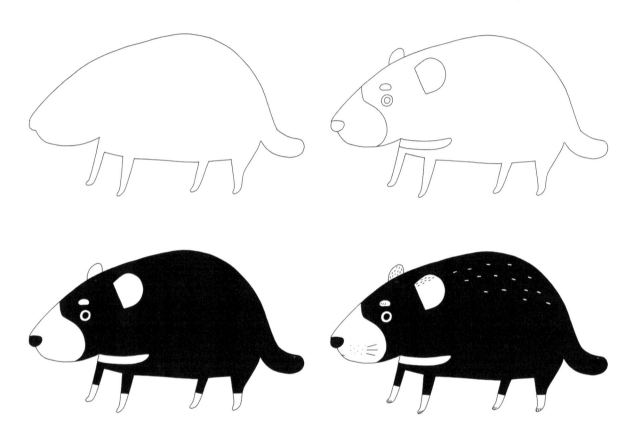

→**TIP**← There's more than one way to add white marks to a dark background—it depends on the medium. For graphite or colored pencil, you can use a very narrow eraser to accurately lift away background value or color. You can also use a finepoint white pen or marker; some brands will also work on ink, watercolor, and gouache. Test your options on sketches before drawing your final artwork.

TRY IT!

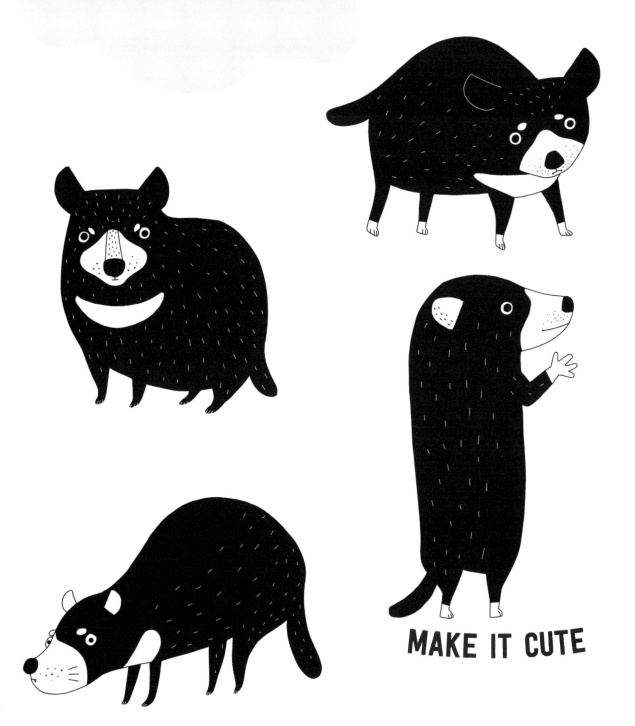

MAKE IT CUTE

DRAW AN ACORN

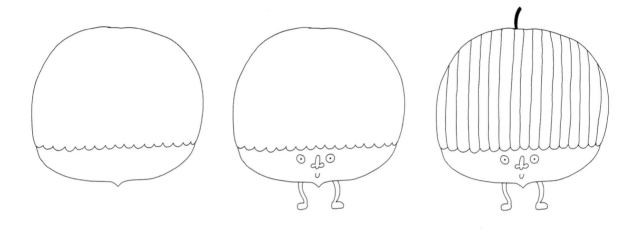

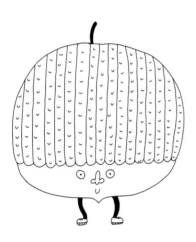

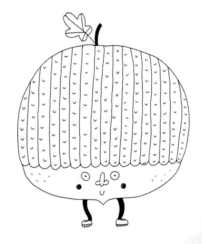

TRY IT!

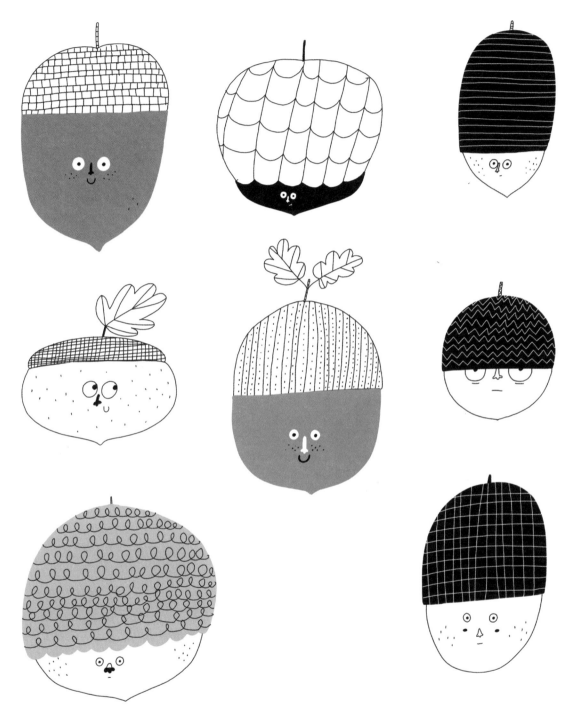

MAKE IT CUTE

DRAW AN ANGELFISH

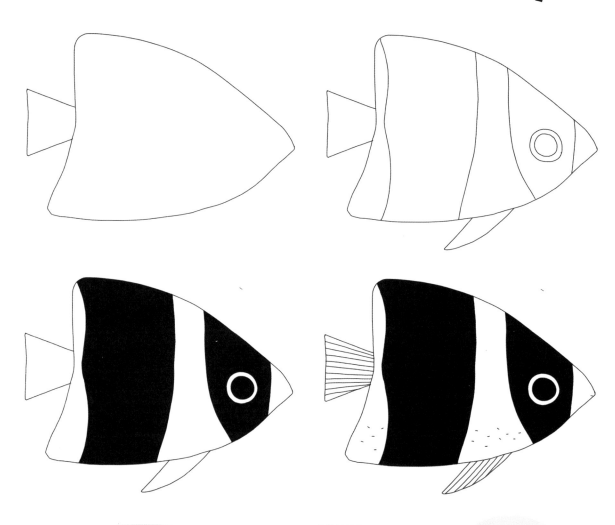

TRY IT!

66

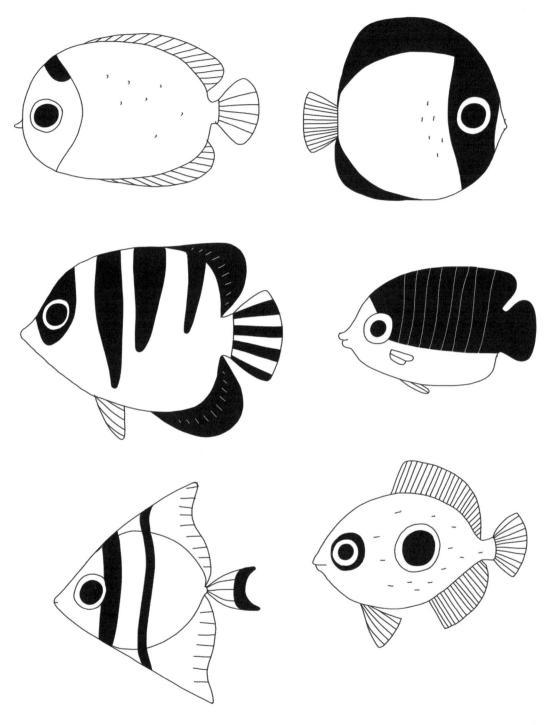

MAKE IT CUTE

DRAW AN AVOCADO

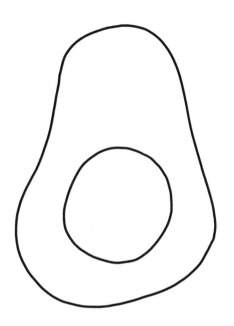

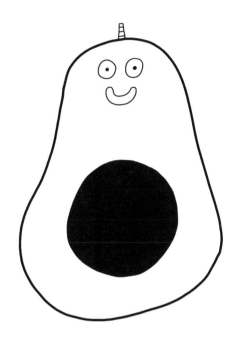

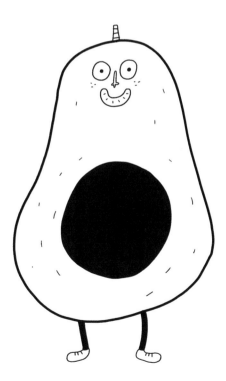

TRY IT!

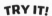

MAKE IT CUTE

DRAW A GRASSHOPPER

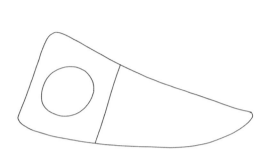
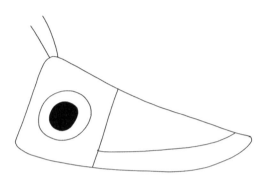
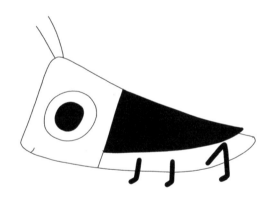
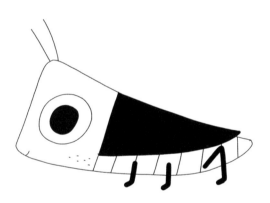

TRY IT!

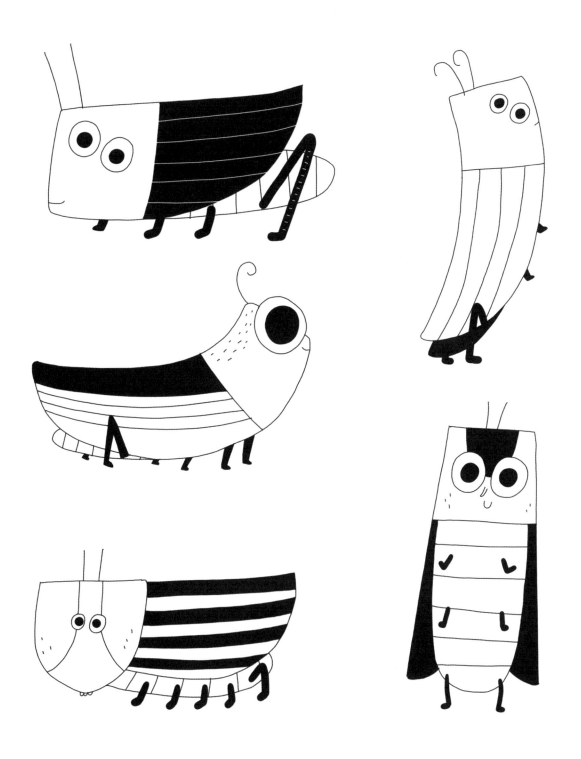

MAKE IT CUTE

DRAW A RAINBOW

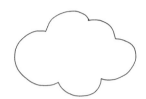 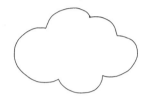 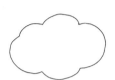

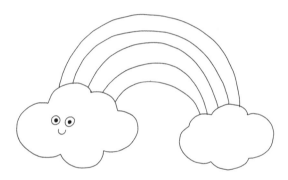 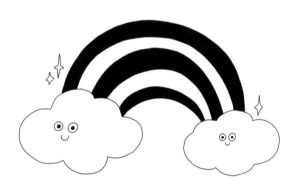

TRY IT!

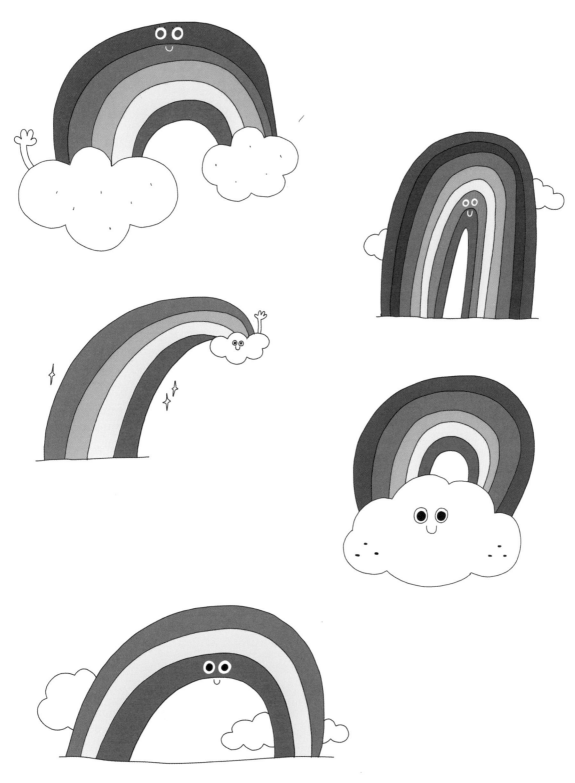

MAKE IT CUTE

DRAW A SUNFLOWER

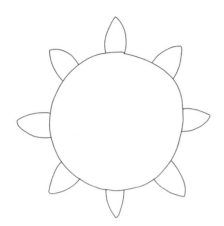

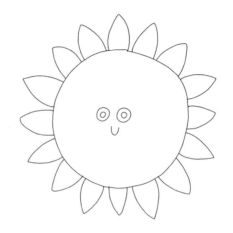

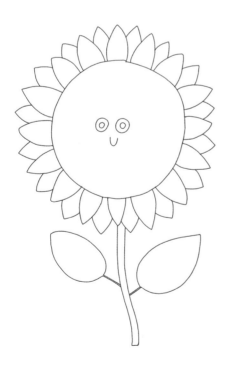

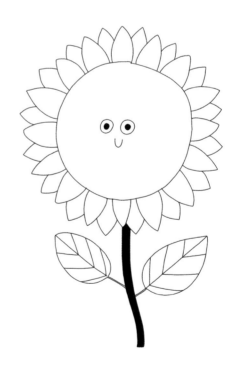

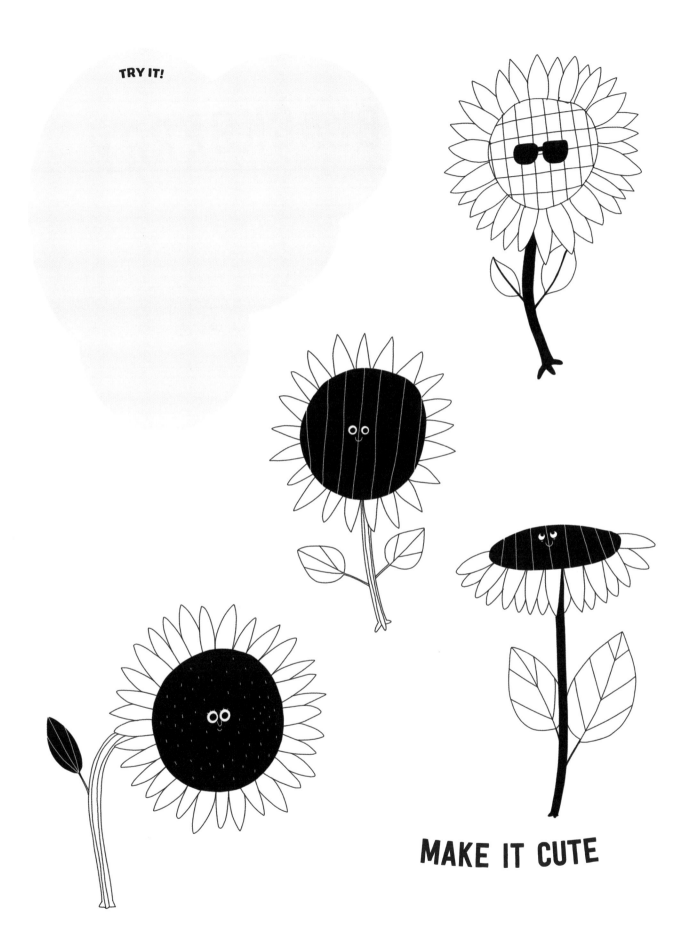

TRY IT!

MAKE IT CUTE

DRAW A BLACKBERRY

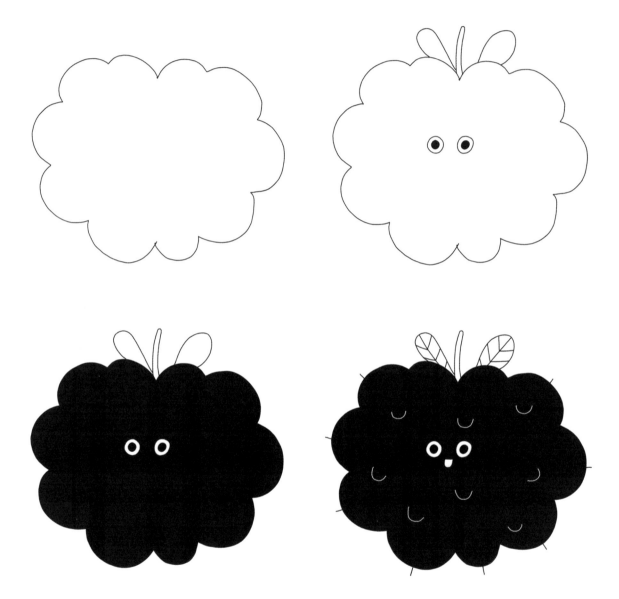

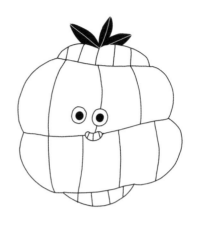

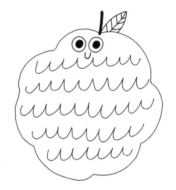

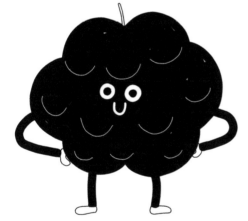

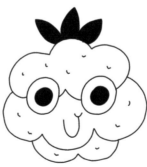

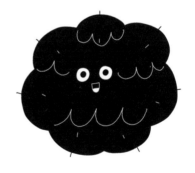

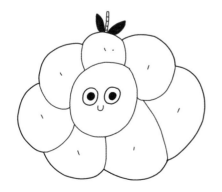

MAKE IT CUTE

DRAW A SHRIMP

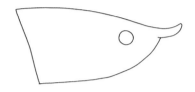

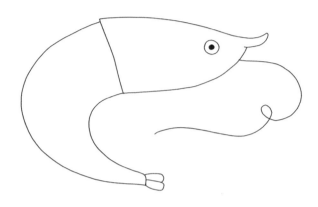

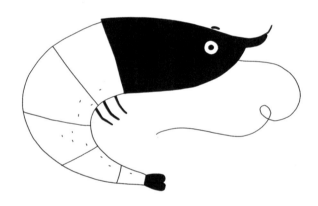

TRY IT!

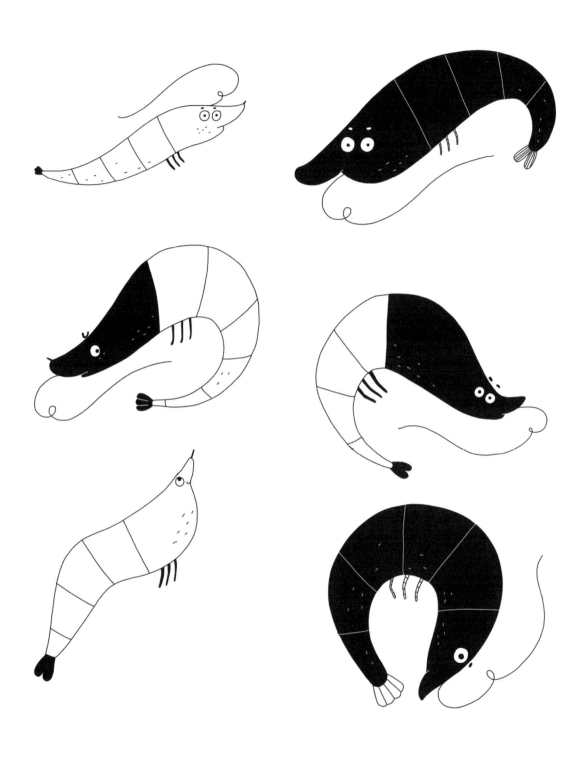

MAKE IT CUTE

DRAW A CARROT

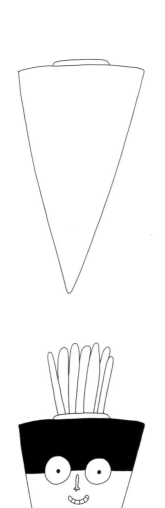

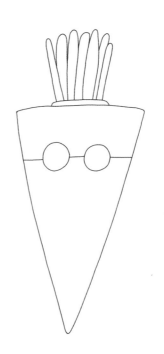

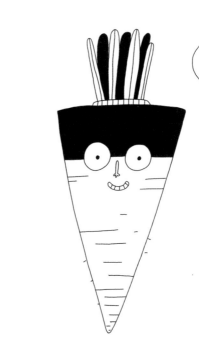

TRY IT!

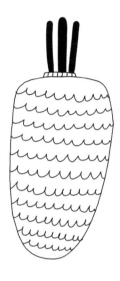

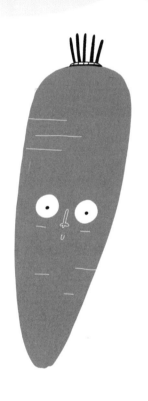

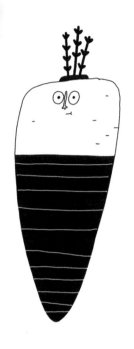

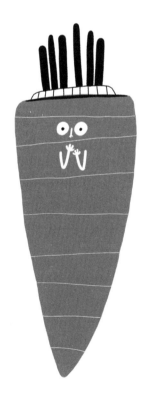

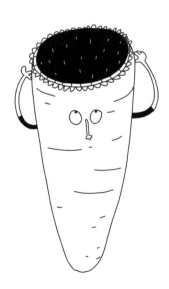

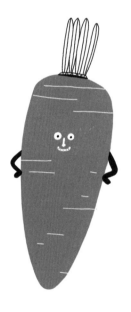

MAKE IT CUTE

DRAW A DINOSAUR

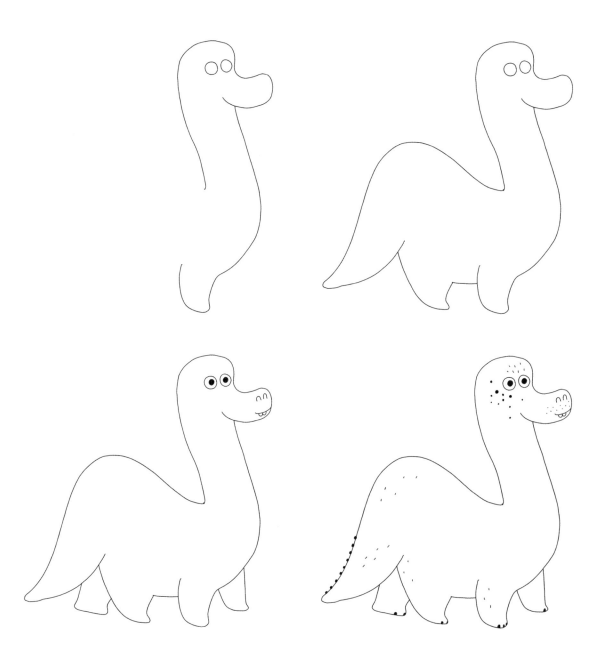

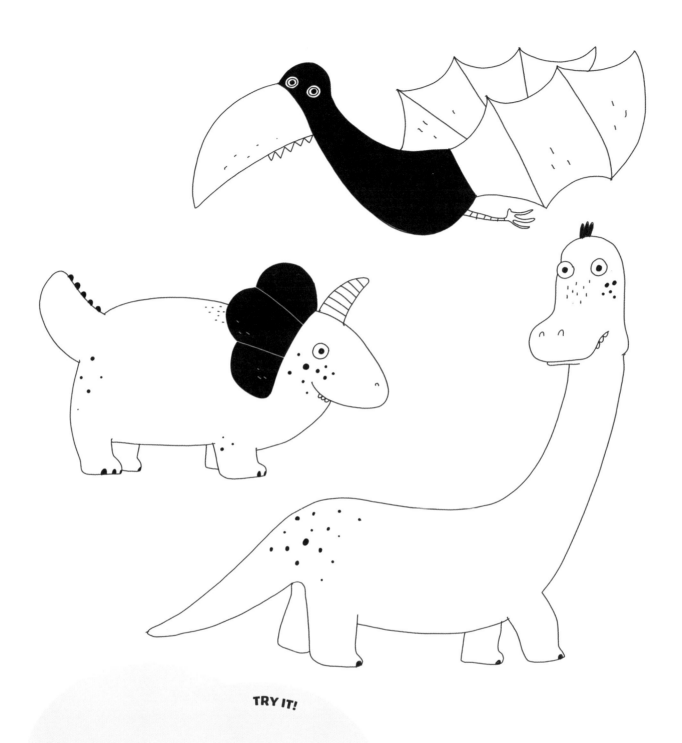

TRY IT!

MAKE IT CUTE

DRAW A CACTUS

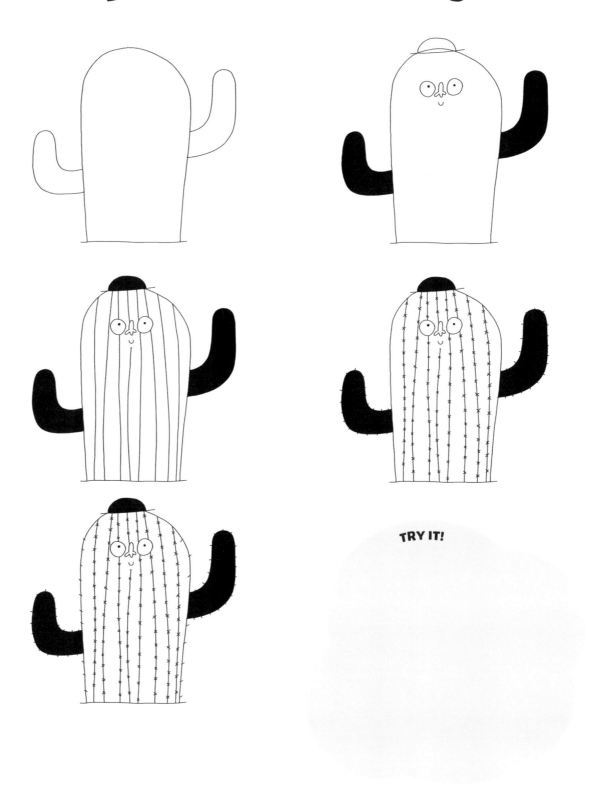

TRY IT!

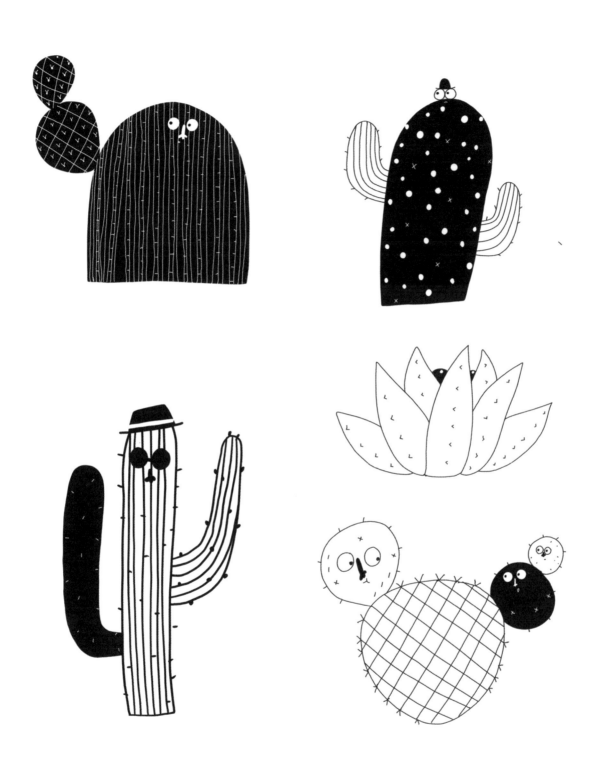

MAKE IT CUTE

DRAW A BOAR

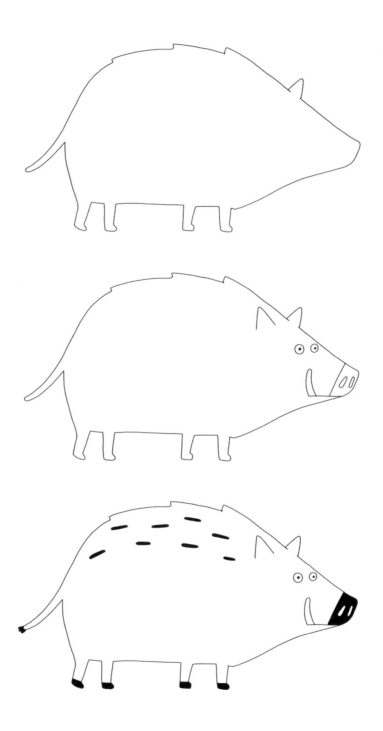

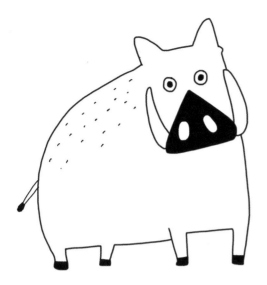

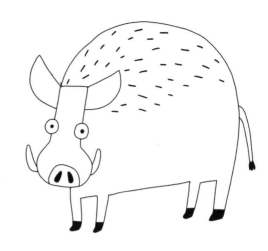

TRY IT!

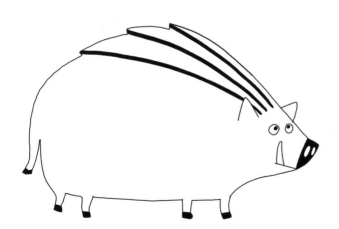

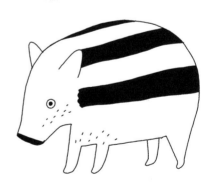

MAKE IT CUTE

DRAW AN APPLE

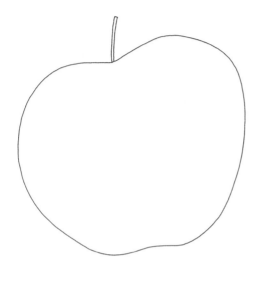

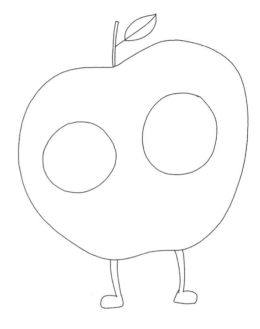

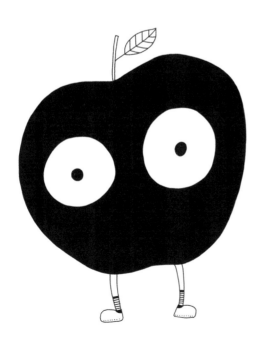

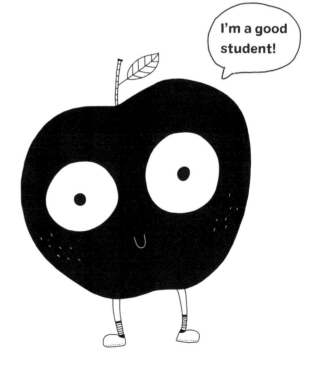

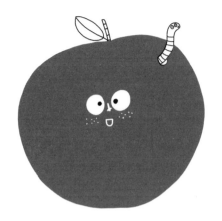

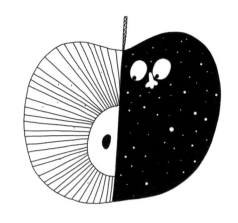

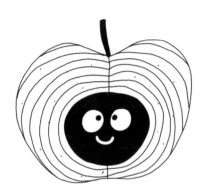

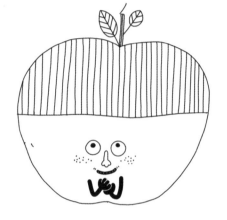

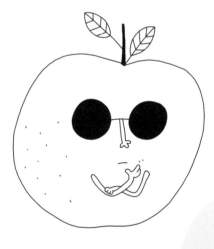

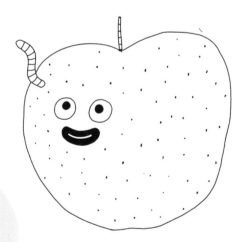

TRY IT!

MAKE IT CUTE

DRAW A SEAHORSE

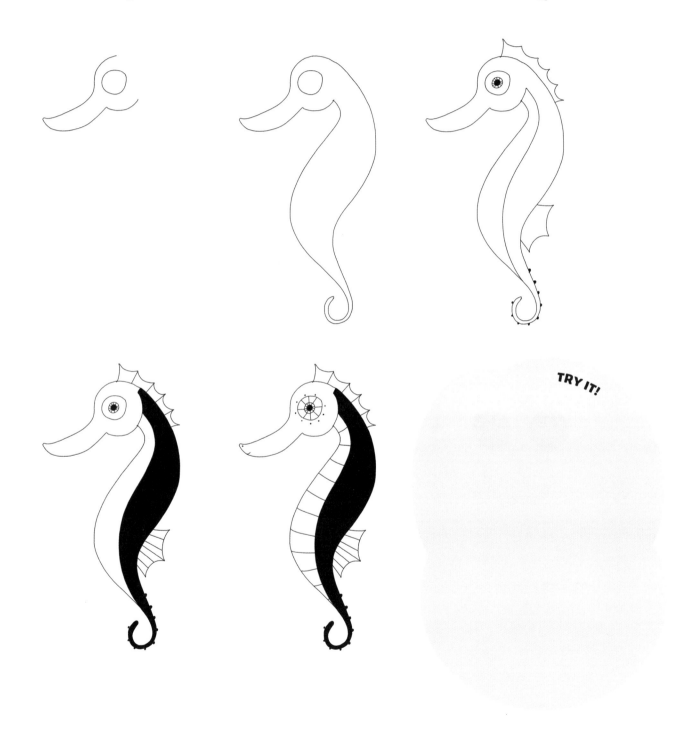

TRY IT!

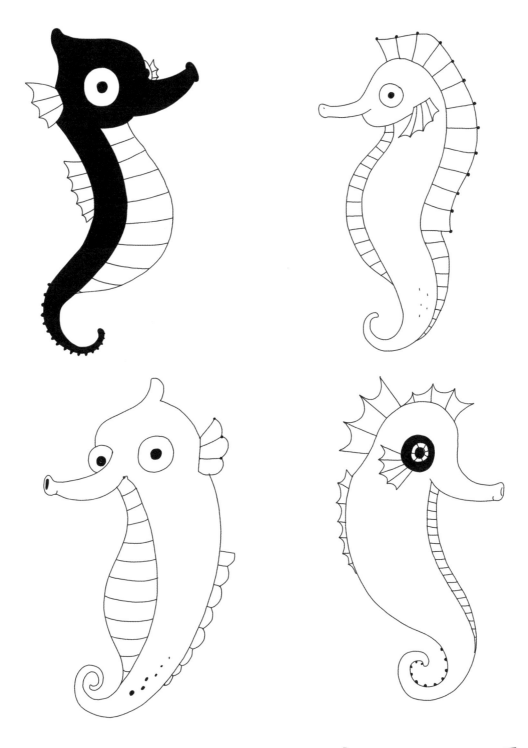

MAKE IT CUTE

DRAW AN ANT

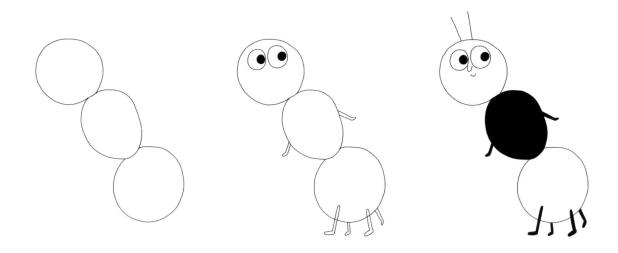

TRY IT!

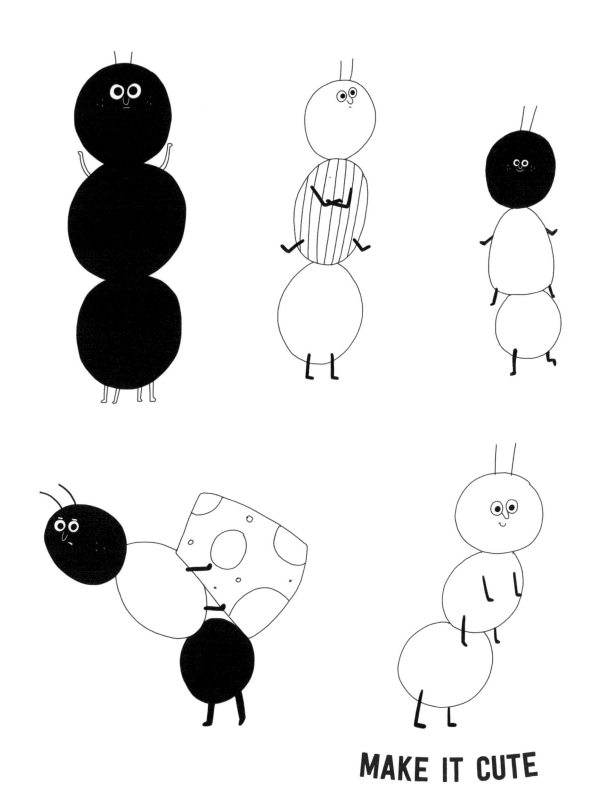

MAKE IT CUTE

DRAW A BROCCOLI

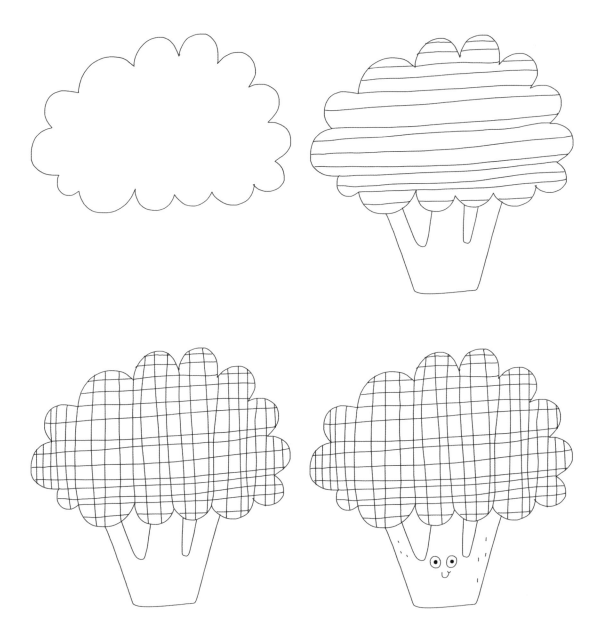

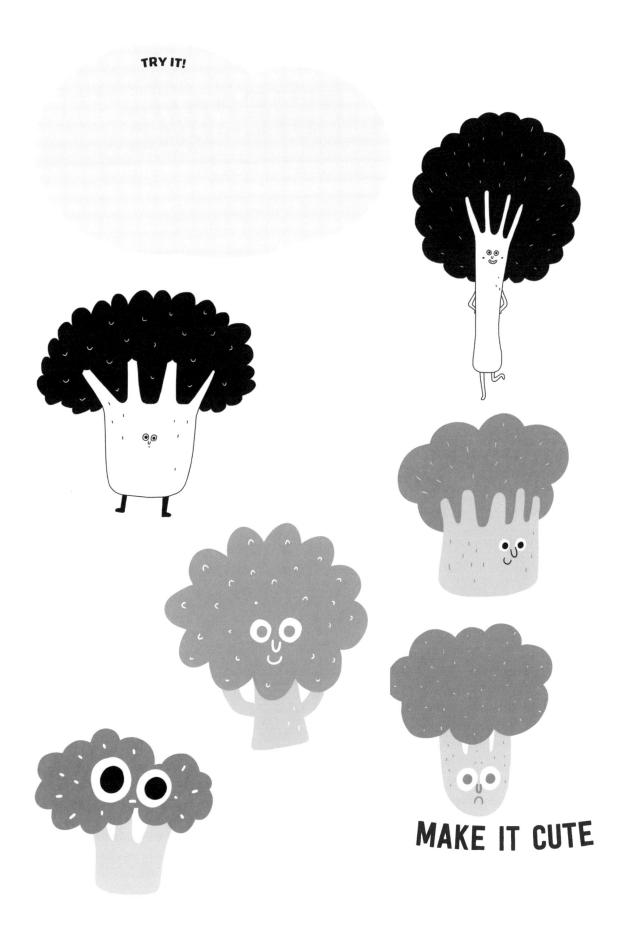

MAKE IT CUTE

DRAW A PINECONE

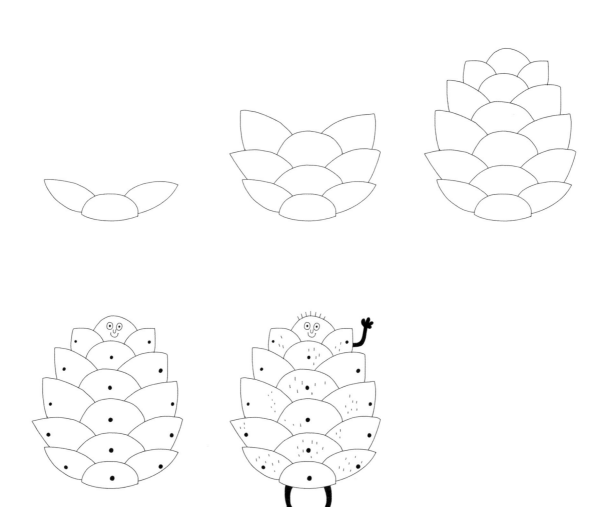

→TIP← To draw a form with overlapping elements like a pine cone, you can start at either the broadest or narrowest end. You can draw a cone with open scales, like the one shown above, or with flat, closed ones, like the two variations shown opposite.

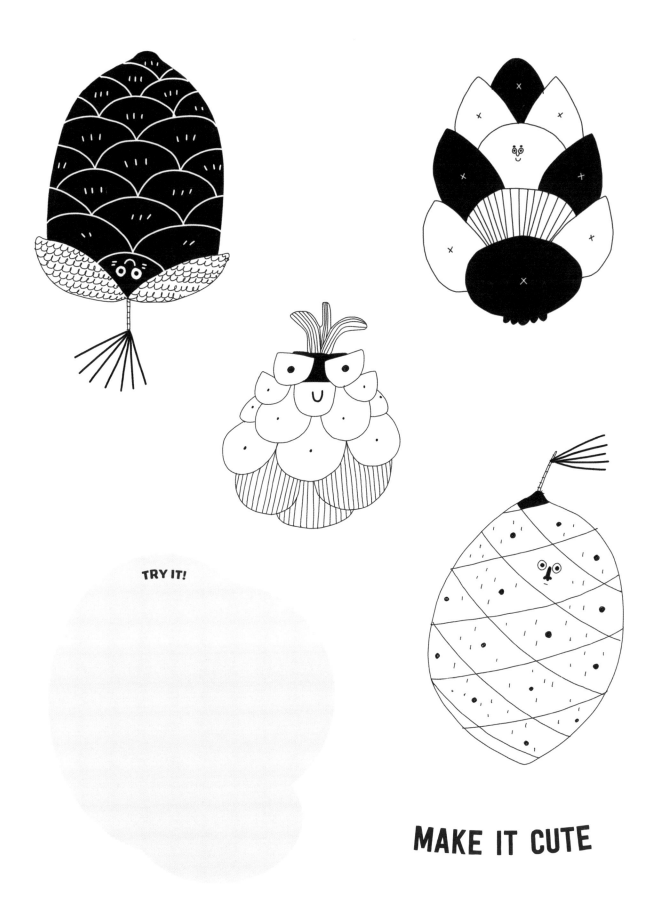

TRY IT!

MAKE IT CUTE

DRAW A PEAPOD

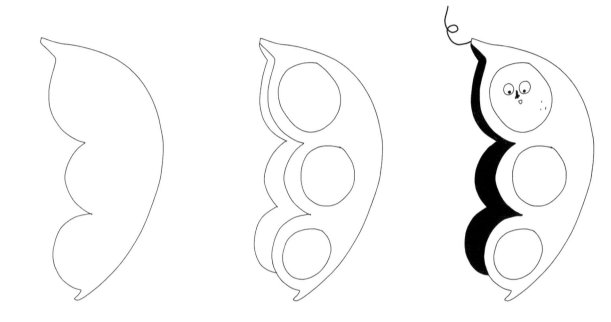

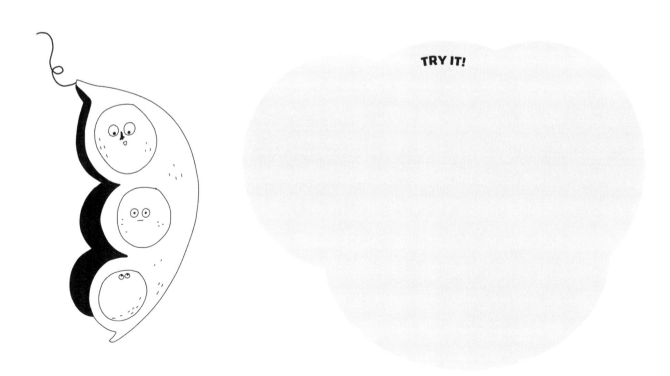

TRY IT!

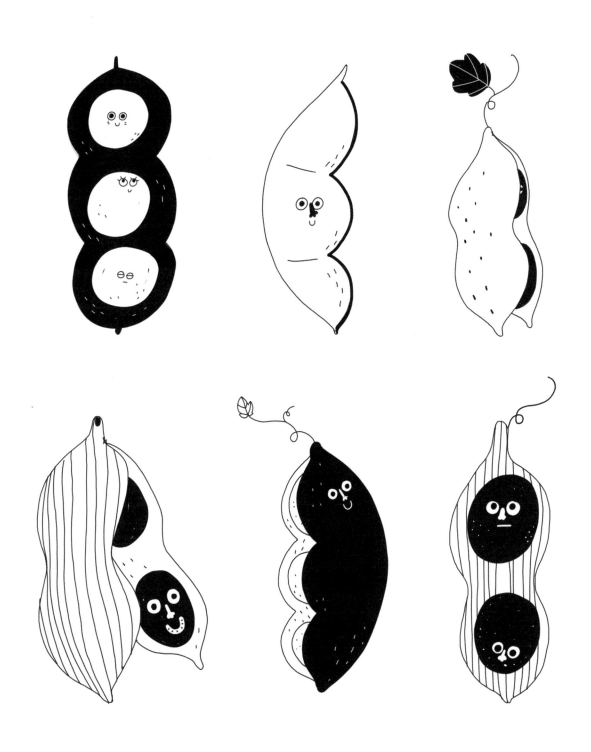

MAKE IT CUTE

DRAW A PLANET

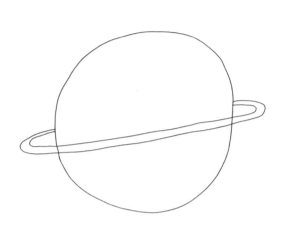

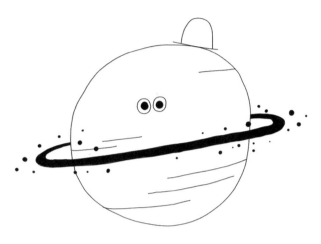

TRY IT!

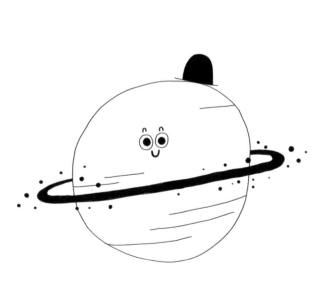

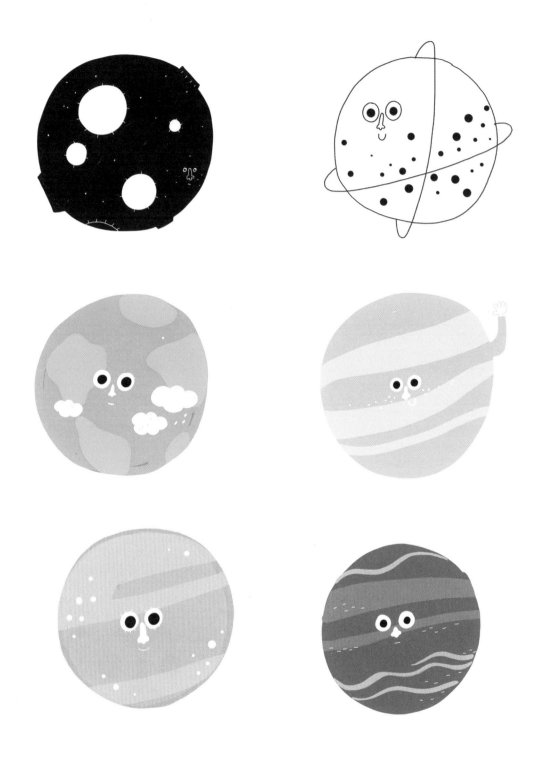

MAKE IT CUTE

DRAW A SPIDER

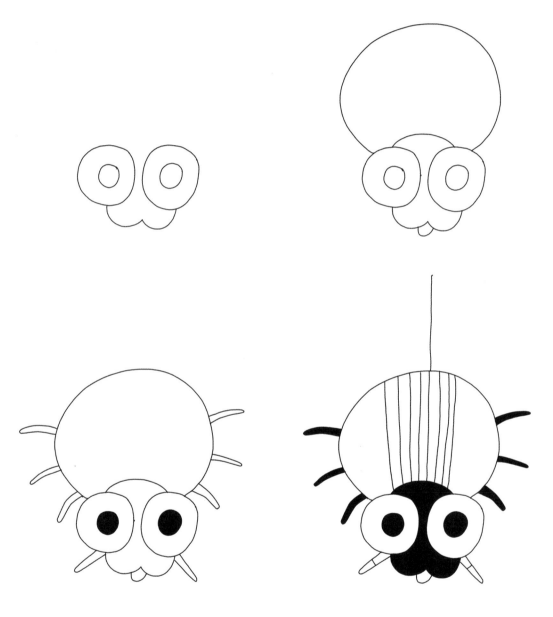

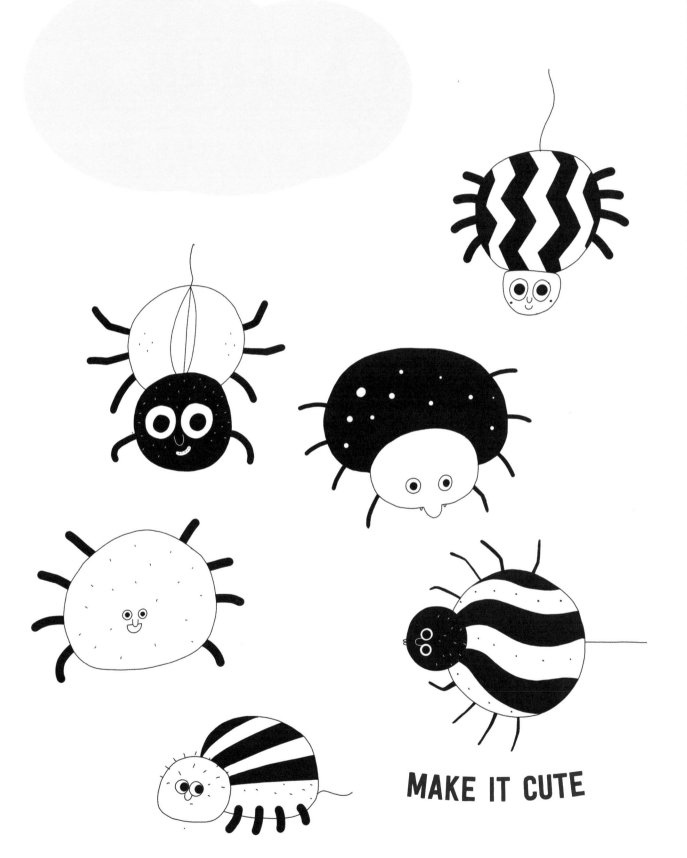

MAKE IT CUTE

DRAW A LEMON

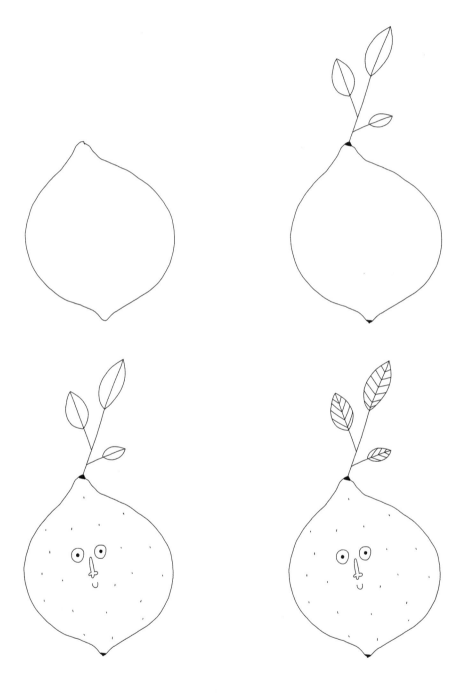

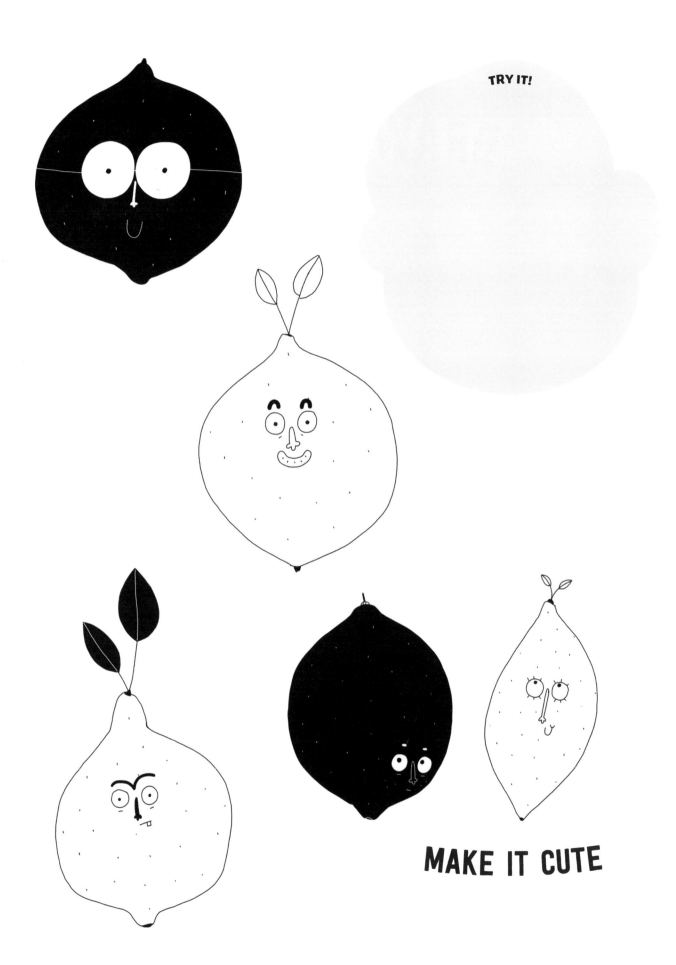

TRY IT!

MAKE IT CUTE

DRAW A ROSE

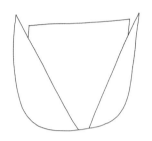

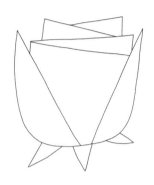

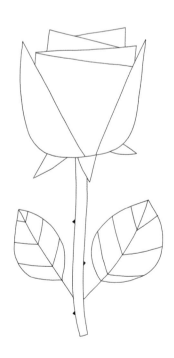

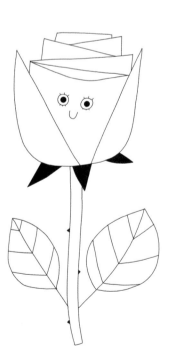

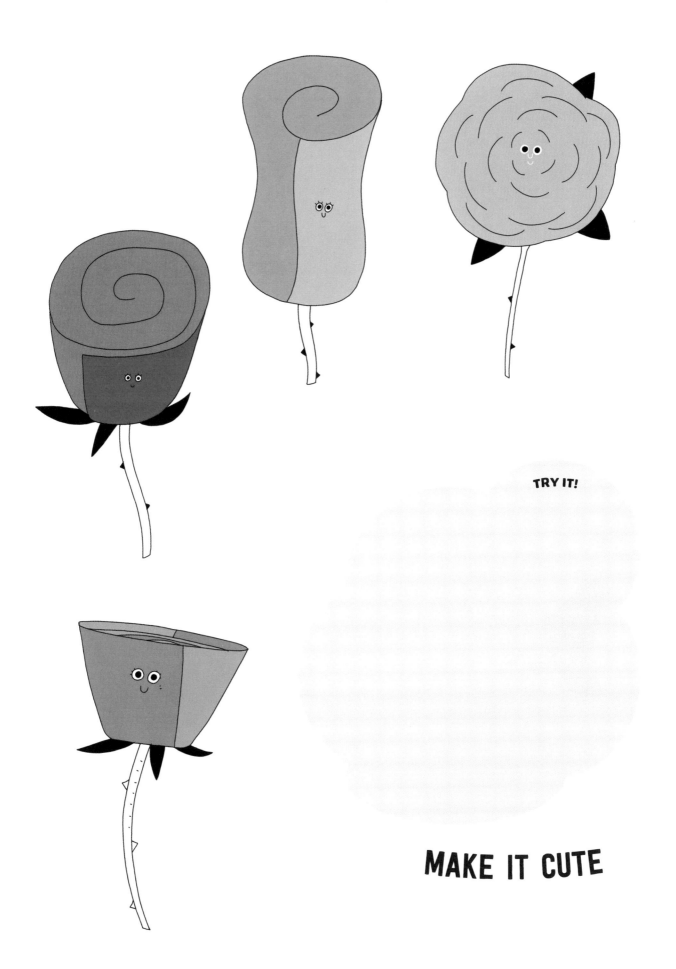

TRY IT!

MAKE IT CUTE

DRAW A FRENCH BULLDOG

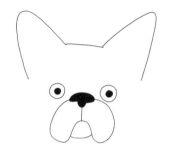

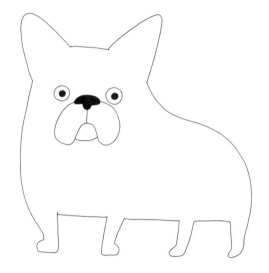

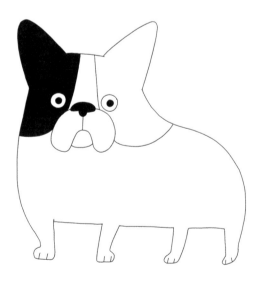

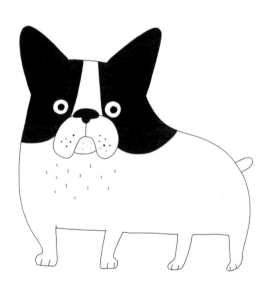

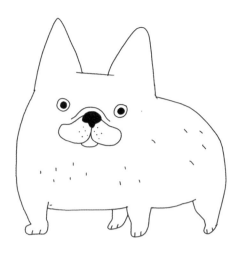

TRY IT!

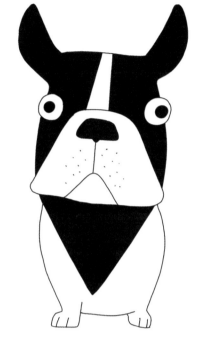

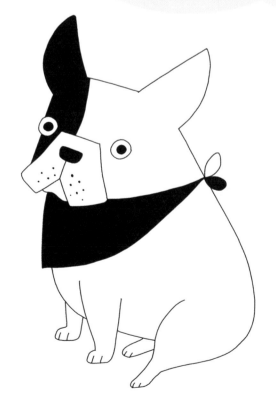

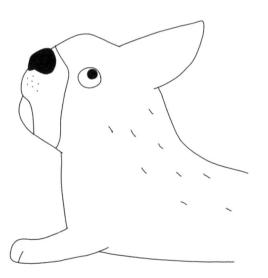

MAKE IT CUTE

DRAW A TURNIP

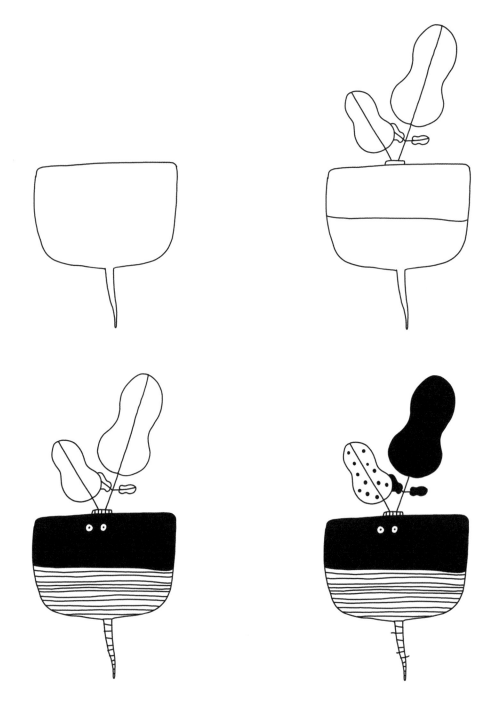

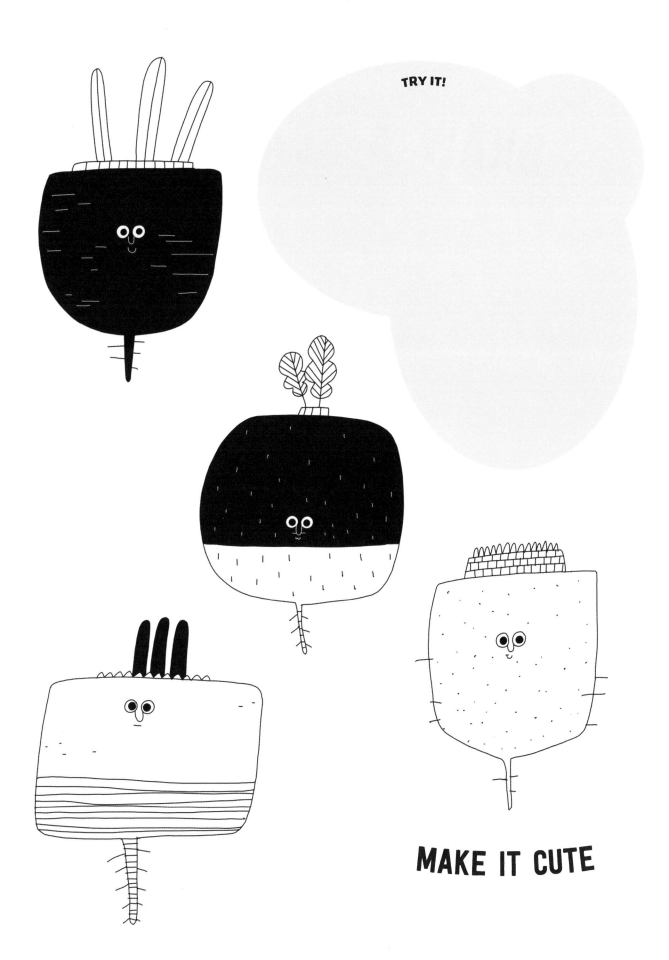

TRY IT!

MAKE IT CUTE

DRAW A SEAWEED

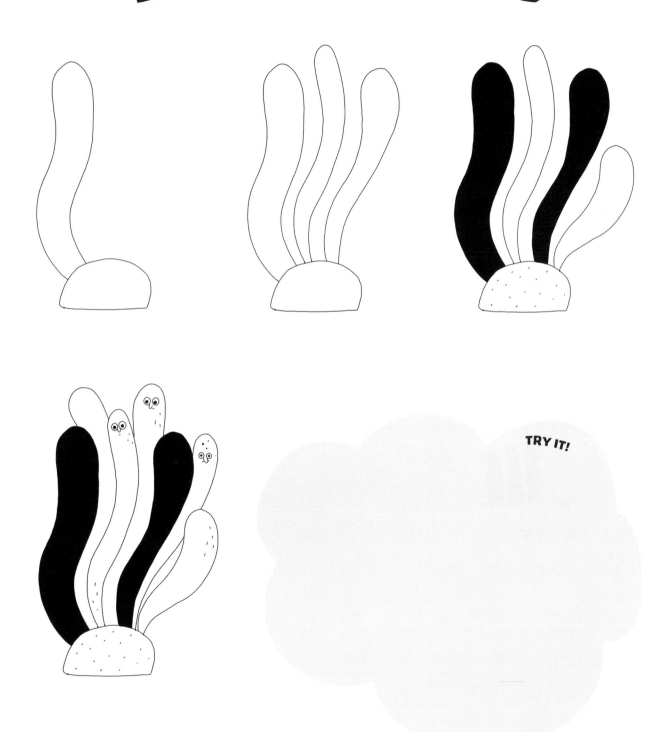

TRY IT!

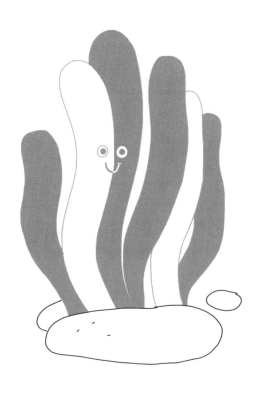

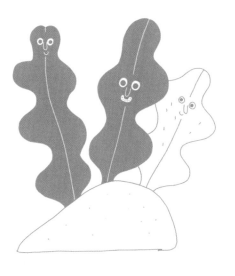

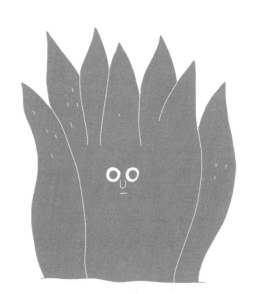

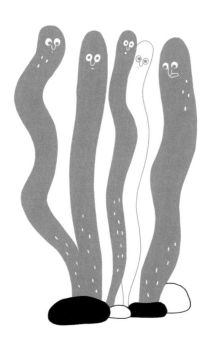

MAKE IT CUTE

DRAW AN AXOLOTL

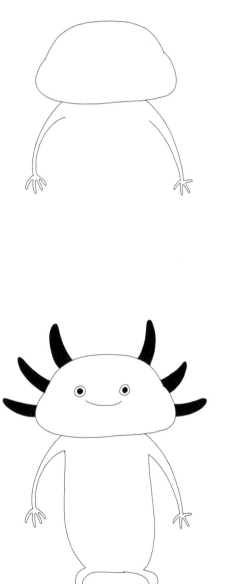
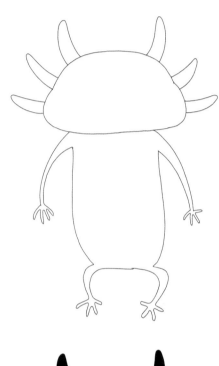
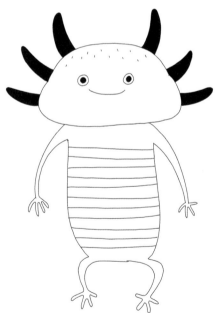

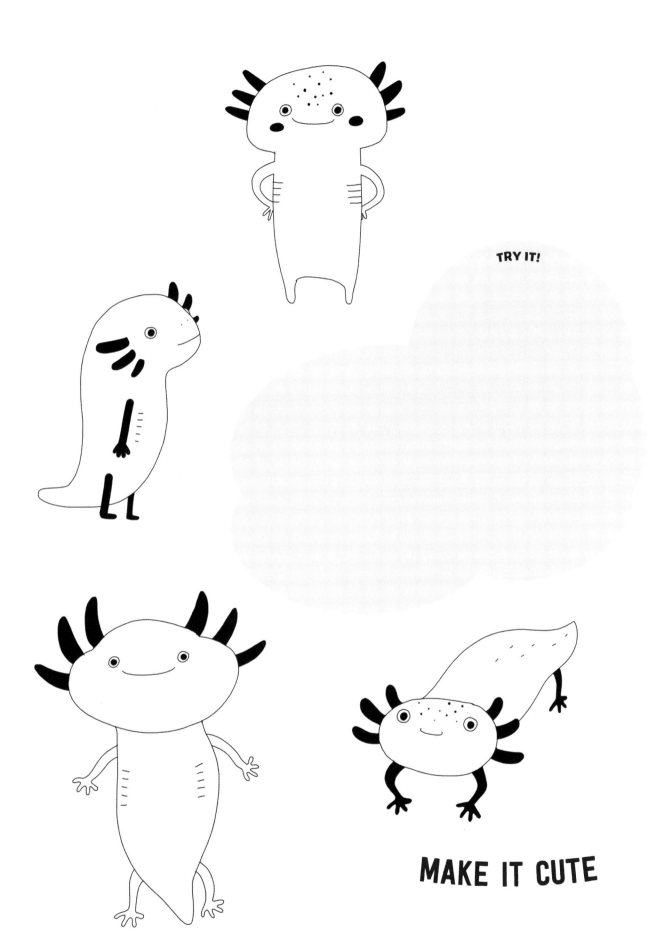

MAKE IT CUTE

DRAW A CATERPILLAR

TRY IT!

→**TIP**← To draw a super-easy caterpillar, use a series of overlapping circles, then add any combination of colors and textures. Another easy shape to try: A very short, chubby snake with a ribbed tummy.

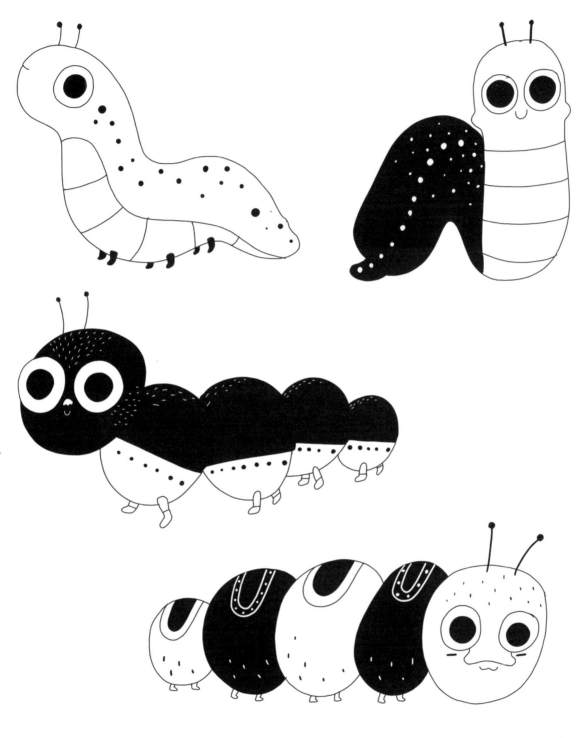

MAKE IT CUTE

DRAW A PUMPKIN

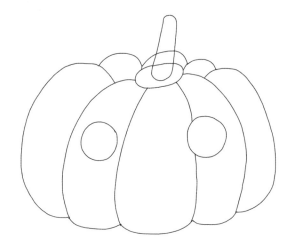
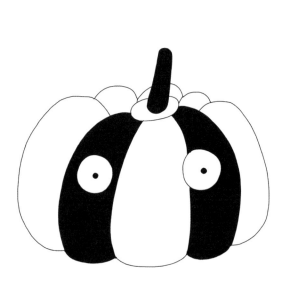
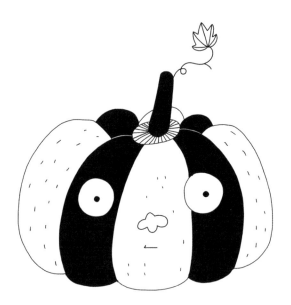

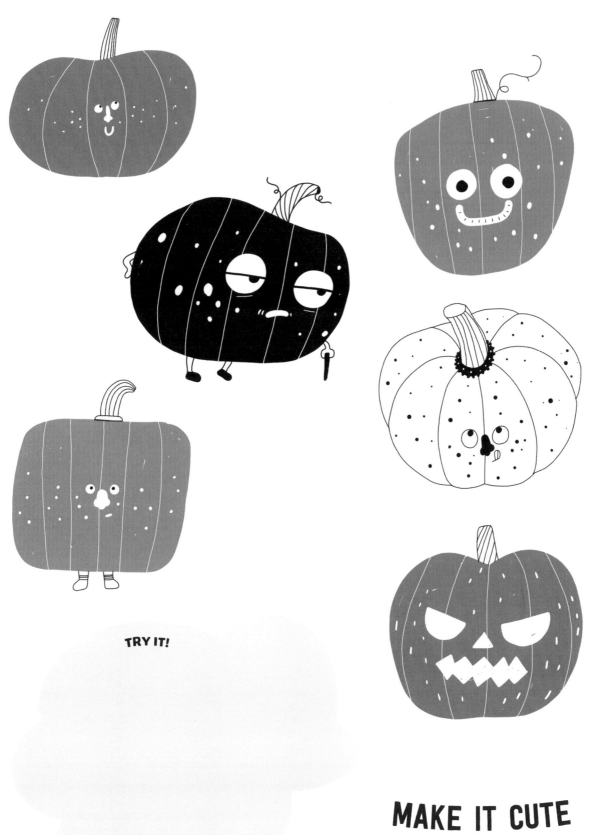

TRY IT!

MAKE IT CUTE

DRAW A BAOBAB

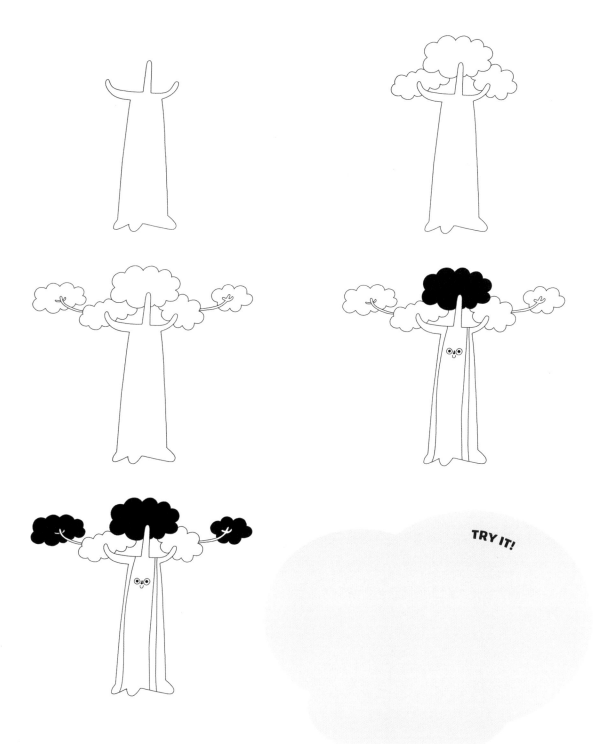

TRY IT!

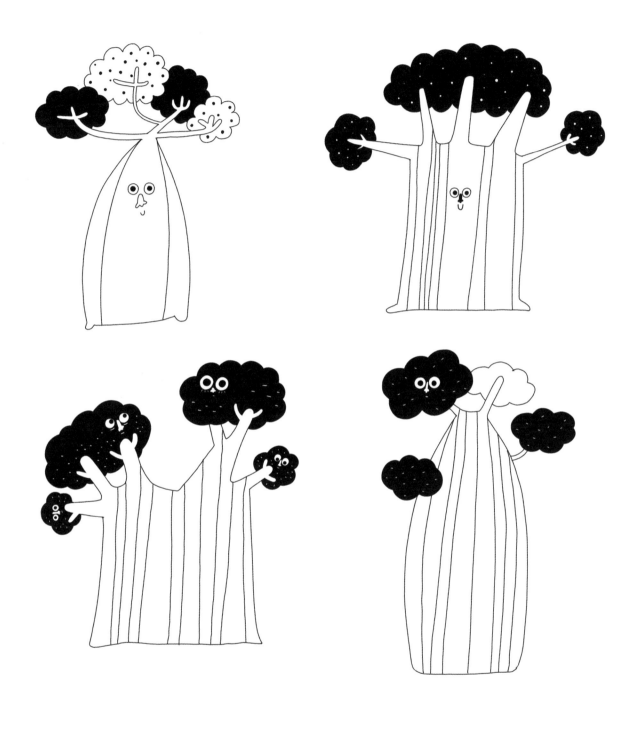

MAKE IT CUTE

DRAW A MOOSE

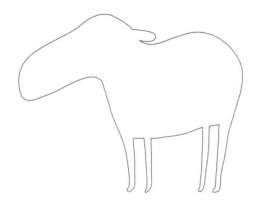
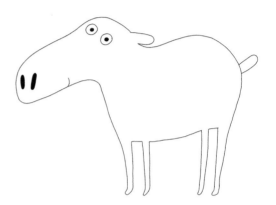

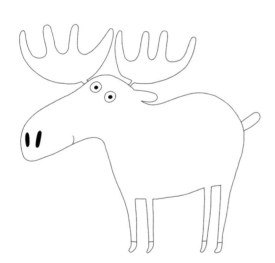
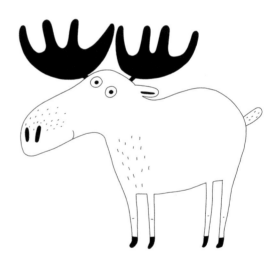

TRY IT!

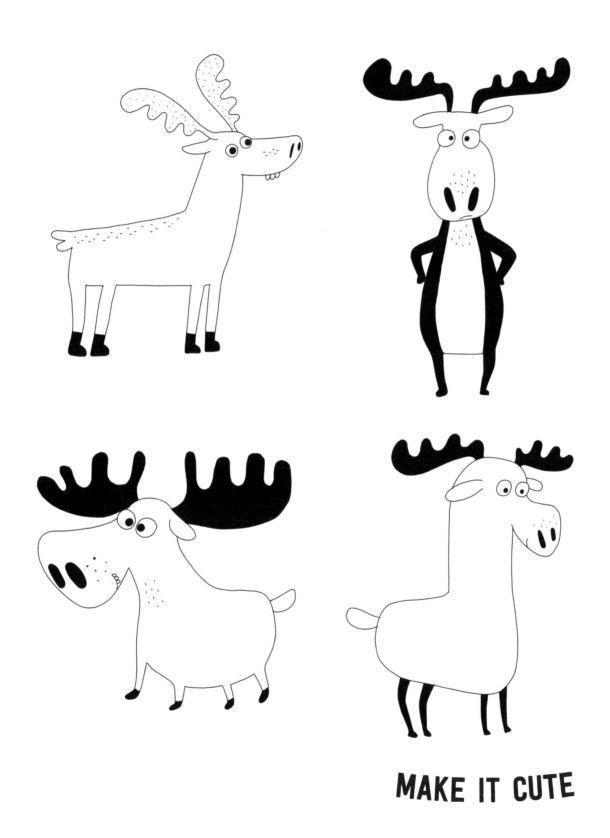

MAKE IT CUTE

DRAW AN OLIVE

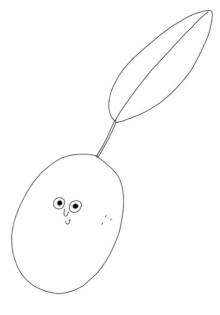

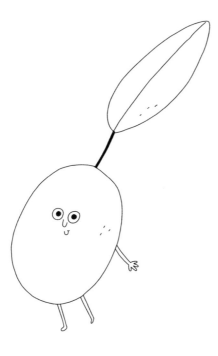

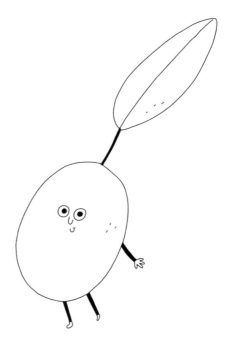

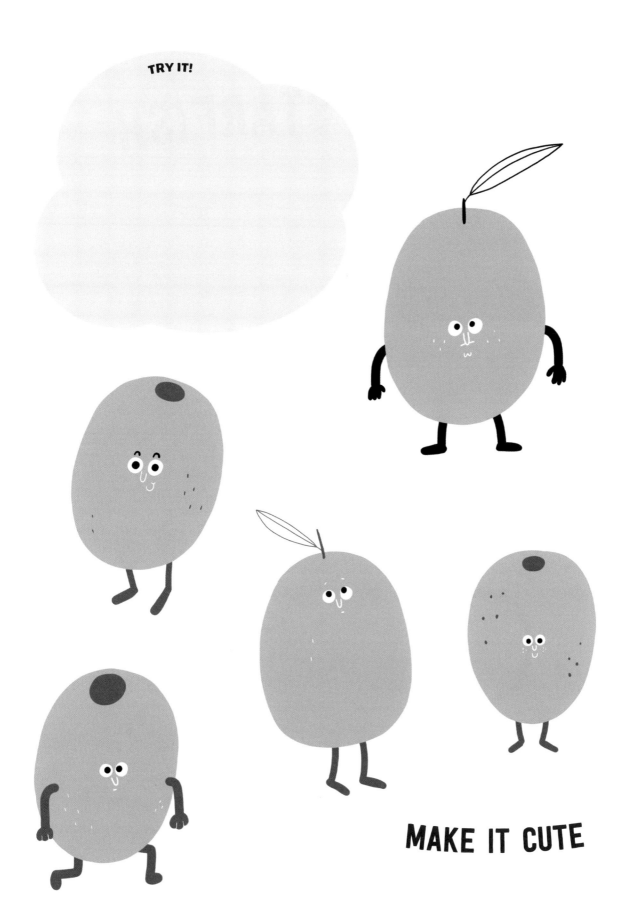

TRY IT!

MAKE IT CUTE

DRAW A STARFISH

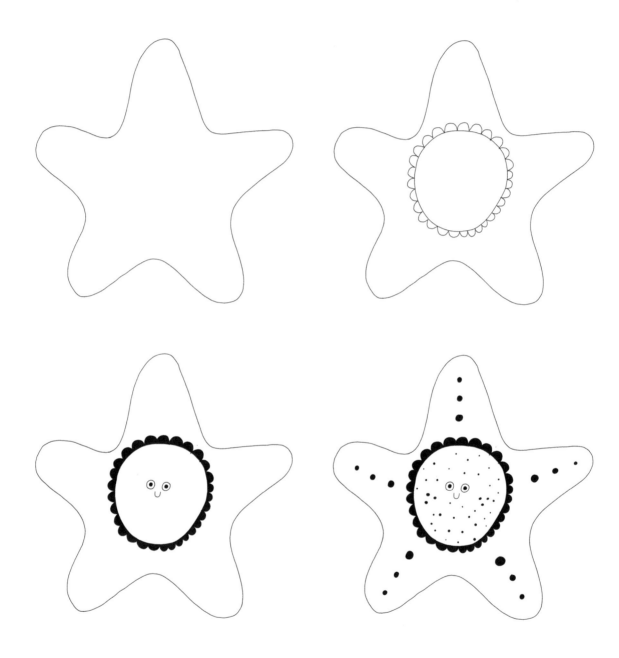

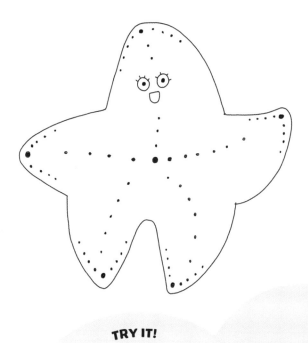

TRY IT!

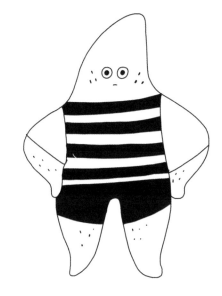

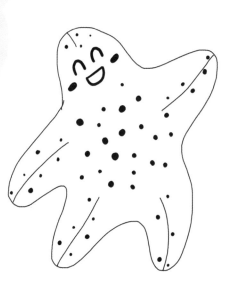

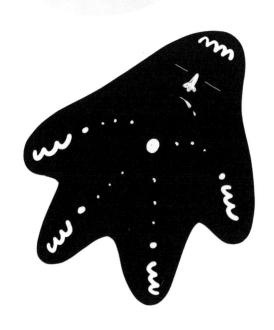

MAKE IT CUTE

ABOUT THE AUTHOR

Heegyum Kim is a graphic designer and illustrator. She holds a
Master of Science in Communication Design from Pratt Institute
and is the author of two illustrated books featuring Mr. Fox, the
charming and humorous character whose activities and musings
drive her popular Instagram account and make her followers giggle,
as do a menagerie of other delightful animal friends. She is also the
author and illustrator behind the Draw 62 Cute series of books, which
provide step-by-step instructions for drawing different types of cute
characters. She lives in Jersey City, New Jersey. Follow her drawing
adventures on Instagram: instagram.com/hee_cookingdiary/

Inspiring | Educating | Creating | Entertaining

Brimming with creative inspiration, how-to projects, and useful
information to enrich your everyday life, Quarto Knows is a favorite
destination for those pursuing their interests and passions. Visit our
site and dig deeper with our books into your area of interest:
Quarto Creates, Quarto Cooks, Quarto Homes, Quarto Lives,
Quarto Drives, Quarto Explores, Quarto Gifts, or Quarto Kids.

First Published in 2020 by Quarry Books, an imprint of The Quarto Group,
100 Cummings Center, Suite 265-D, Beverly, MA 01915, USA.
T (978) 282-9590 F (978) 283-2742 QuartoKnows.com

Quarry Books titles are also available at discount for retail, wholesale,
promotional, and bulk purchase. For details, contact the Special Sales
Manager by email at specialsales@quarto.com or by mail at
The Quarto Group, Attn: Special Sales Manager, 100 Cummings Center,
Suite 265-D, Beverly, MA 01915, USA.

10 9 8 7 6 5 4 3 2 1

ISBN: 978-1-63159-945-3

Digital edition published in 2020
eISBN: 978-1-63159-946-0

Design: Debbie Berne

Printed in China

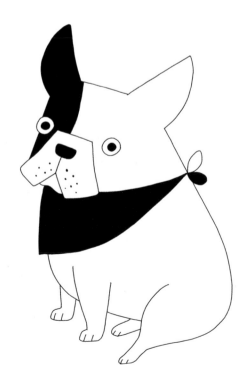